Michael DeLucia

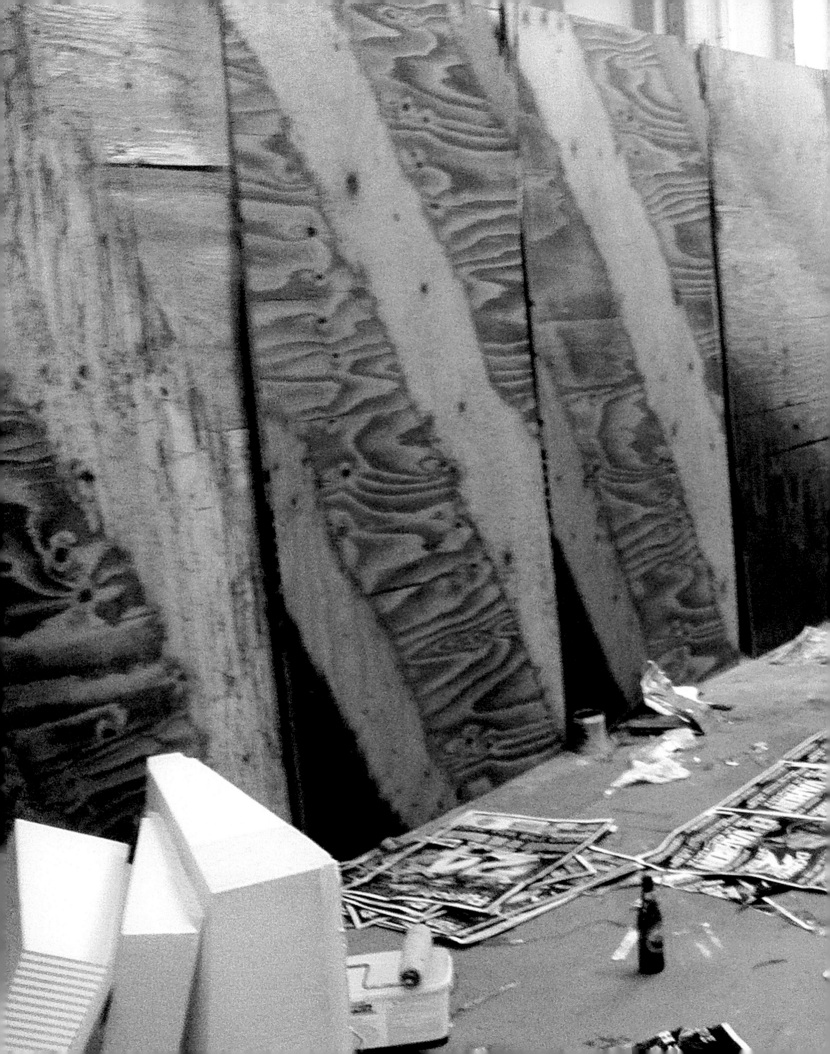

Michael DeLucia

black dog
publishing
london uk

to my boy Louis

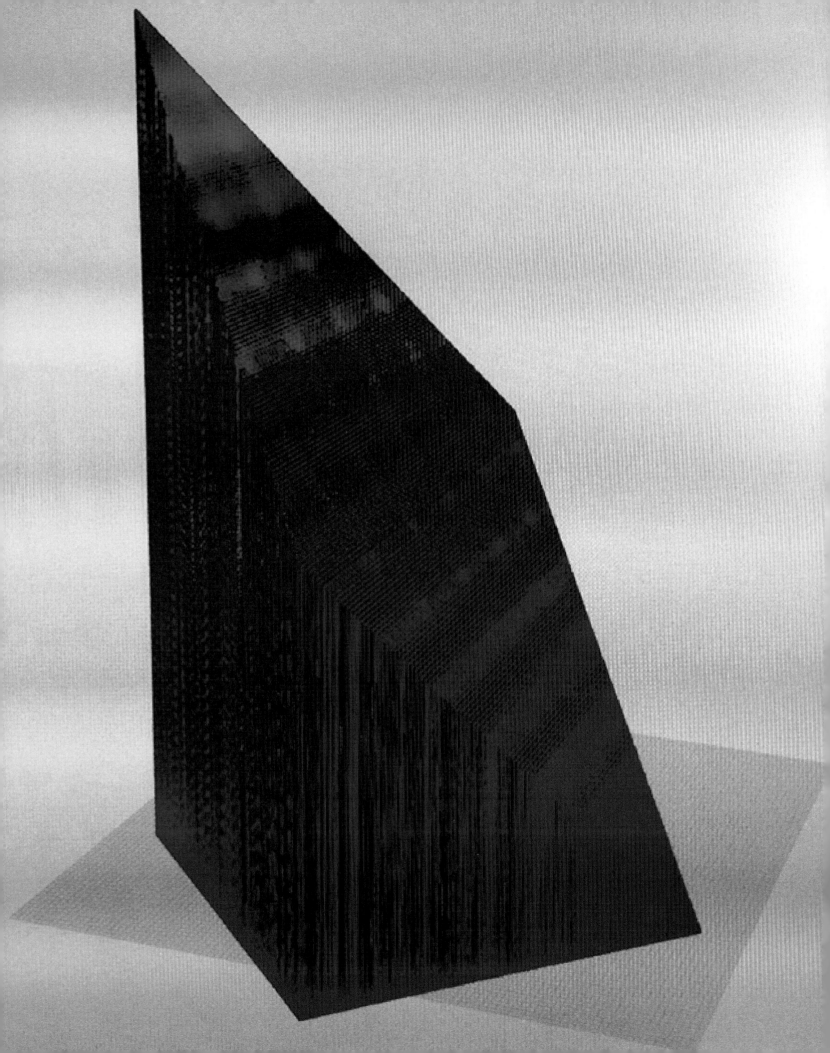

CONTENTS

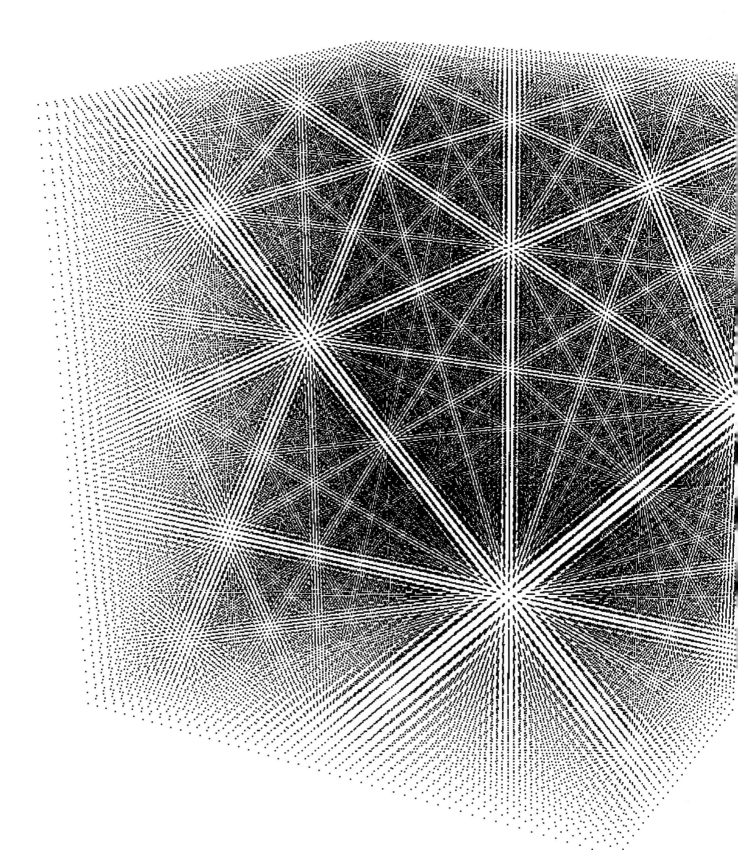

LIMINAL ZONES

Kristen Chappa

Public art projects are notoriously contentious, and Michael DeLucia's 2010 untitled sculpture in downtown Brooklyn was no exception. Installed at the MetroTech Center in collaboration with the Public Art Fund, the piece was constructed using 13 chain link fences. The structures were erected one directly in front of the other, in a serial manner that formed an open cube shape, visible in cross-sections from its two sides. The brilliance of the work's conception lay in the shimmering visual effect manifested by DeLucia's deceptively simple gesture—when viewed moving past the work's front or back faces, the spatial layering created an Op Art illusion in three-dimensions.

Public art exacerbates the difficulty, if not impossibility, of pleasing everyone—both those with and without a vested interest in, and specialized knowledge of, contemporary art and art history. DeLucia's sculpture was installed at a busy thoroughfare surrounded by nondescript architecture designated for government, education, and corporate use. Some members of the general public failed to identify the piece as an artwork when it was installed; one man thanked the artist when the sculpture was being removed. Considering the perspective of commuters who must traverse the MetroTech area on a daily basis, the desire for large-scale public art to offer temporary respite from its looming drudgery is not unrelatable.

Ironically, the piece did, in fact, function in just this way. By repeating the fencing in a straightforward manner, DeLucia transformed the quotidian material into something otherworldly. However, the individual fences themselves carry such strong associations that some viewers did not see past them, missing the work's cumulative effect. The negative reactions to the piece were undoubtedly tied to this loaded signification. Industrial chain link fences are ubiquitous in the urban landscape—the material is the cheapest means by which to parcel and segregate space in zones of development, as well as other sites such as schools, playgrounds, and prisons. A frustrating paradox is embedded in its functionality, preventing access but offering a view onto

previous page
Point Cloud (from *Artifacts*),
2007
digital model
screen capture from 3d
interactive PDF
Collection of the Artist

opposite
proposal rendering, 2007
from digital model for
Untitled (fences), 2009

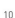

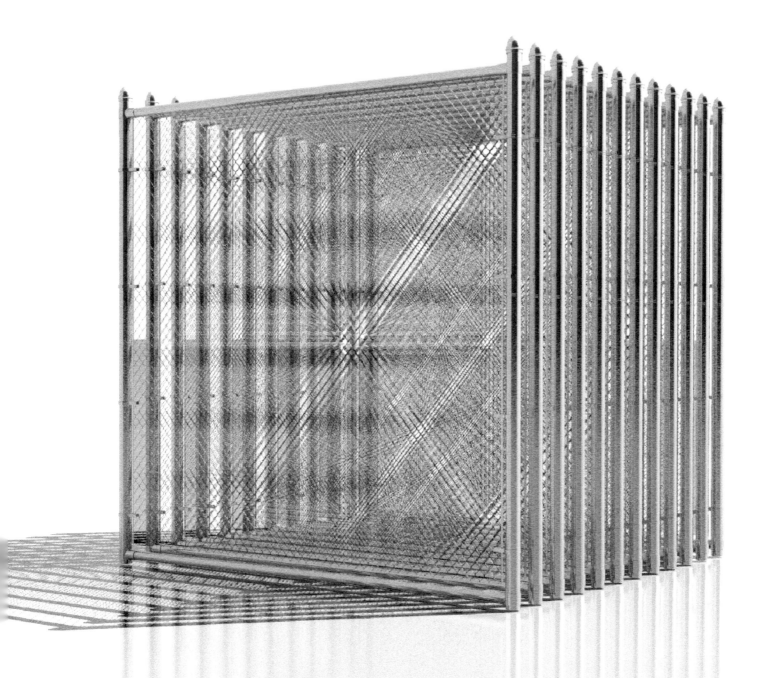

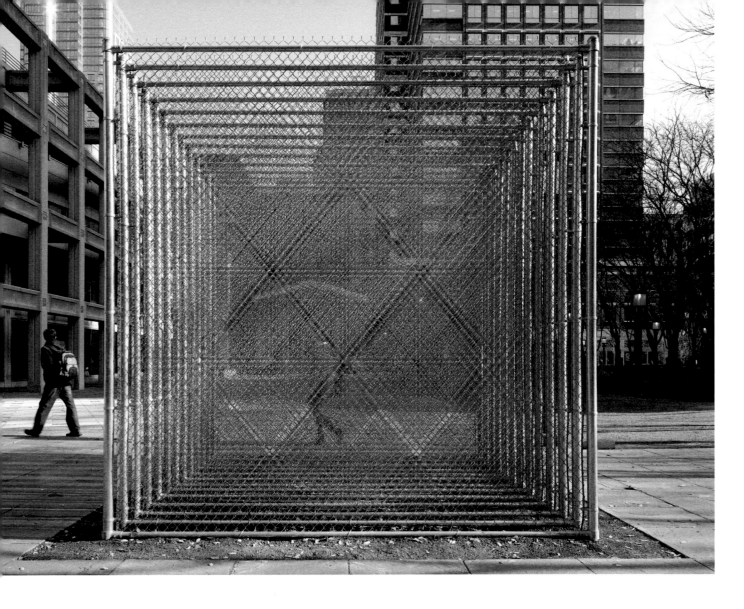

an off-limits expanse. Positioning this particular readymade in a downtown urban setting seeing rapid expansion, and furthermore amplifying this signifier of construction, division, and gentrification through its repetition, was offensive to some. Instead of standing in contrast to the existing environment, the fences blended in, utilizing the materials and language of the site itself.

The MetroTech project speaks to DeLucia's broader practice, which foregrounds the boundary between what is real-world and pure abstraction; routine experience and perceptual surprise. It also highlights his deep interest in the failures, misalignments, and possibilities of translating data between digital and physical mediums. His work often grapples with the division between physical presence and the intangible materials that occupy virtual space. The experience of the untitled public sculpture was not unlike viewing imagery on a computer monitor. In a literal sense, the negative space of the fencing screens superimposed over its background subdivided it into a living moiré pattern, a common optical effect in digital photography. A longing to traverse or reconcile this barrier between physical reality and untouchable virtual space lies at the core of many of DeLucia's investigations.

above
Untitled (fences), 2009
galvanized chain link
fencing
12 × 12 × 12 ft
installation view from
Double Take, presented
by the Public Art Fund, NY
Collection of the Artist

opposite
Untitled (fences), 2009
detail view

DeLucia's artworks often occupy such border-spaces, consistently negotiating the relationship and tension between two- and three-dimensional representation by realizing similar geometric shapes in multiple formats and mediums including wood, Styrofoam, vector-plotted drawings on paper, 3D modeled objects and readymade assemblages. DeLucia identifies as a sculptor with an image-based practice; his output oscillates between flattened perspective and objects in the round. In translating forms between two and three dimensions, as well as physical and digital materials, objects become odd caricatures of themselves as their texture and weight shifts. For example, *The Field*, 2007, a virtual sculpture, reappears as *The Field*, 2009, from DeLucia's body of works using white Styrofoam. Like the act of repeating a word over and over until it becomes foreign to your ear and tongue, these familiar shapes and materials become othered in DeLucia's hands—we gain a certain objective distance and experience them anew. The matte Styrofoam material maintains a relationship to the digital objects created in CAD that possess almost absent, non-surfaces. DeLucia selected Styrofoam as his medium for a considerable number of pieces precisely because it so well approximates the texture, tone,

opposite
The Field (from *Artifacts*), 2007
digital model
screen capture from
3d-interactive PDF
Collection of the Artist

below
The Field, 2009
expanded polystyrene foam
54 × 31 × 36 in
Collection of the Artist

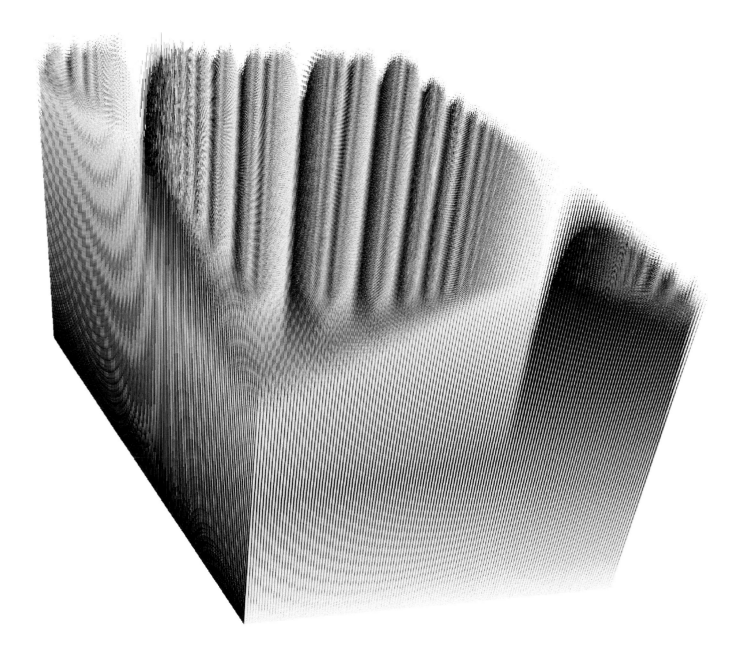

Narcissus, 2010
galvanized steel garbage cans
21¼ × 21¼ × 54 in
Private Collection, Belgium

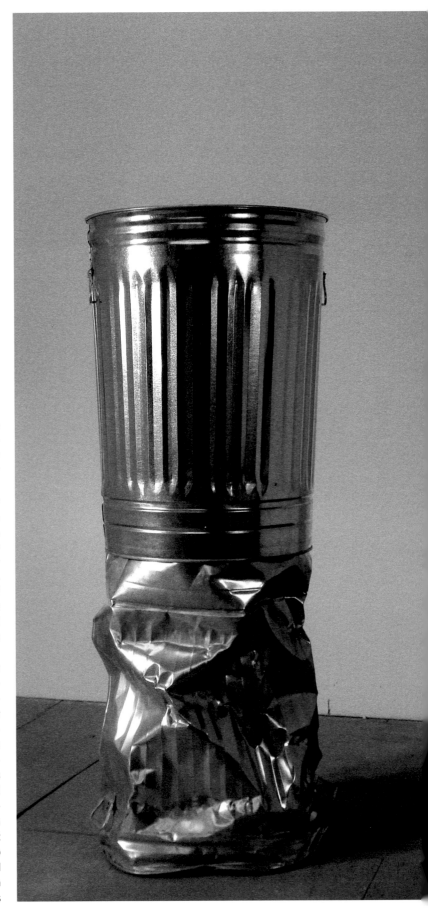

and luminosity of these virtual 'mock up' objects in physical space. The contemporary material also mimics and references more classical mediums, such as stone or plaster—simultaneously celebrating and undermining our nostalgia for them.

Treading various liminal zones informs how the artist treats his materials of choice. A body of modified readymade sculptures made from 2006 to 2011 includes common items from the household and hardware store, such as brooms, wheelbarrows, and aluminum awnings. These earlier investigations contain a prominent horizontal plane, symbolizing for the artist a border between what is real-life and what resides in the abstracted space of the art gallery. Acting like a fence or mirror, these perpendicular planes are a sculptural analog to the picture plane in two-dimensional mediums such as painting. The piece *Racecar*, 2009, comprised of two stacked wheelbarrows, features a formal threshold where the objects meet face to face, just as *Narcissus*, 2010 shows a boundary line between two trash cans—one pristine and the other crumpled and street-worn. The sculpture *Red Shift*, 2007 based on the physical properties of light and water, contains this border-space between many bright orange brush heads that delineate a surface tension, and their handles—slender wooden dowels forming sculptural lines—all set slightly askew. This imagery is further 'refracted' in *Red Shift*'s documentation as it appears in this catalog. The lines of the sculpture's base are once again broken and extended as the book's gutter operates onto the object once again in this digitally modified photograph.

Contextualized by 1960s Minimalism that utilized basic geometry, industrially produced materials, and a systems-based logic, DeLucia's practice complicates that legacy. Distinctions include the works' close relationship to present-day technology and the prominent role of illusionistic space generated by CAD models that exist as works online or drawn onto paper and carved into plywood. DeLucia's computer-aided process of routing three-dimensional forms—such as spheres, cones, cubes, and stock models—onto flat wood panels cuts grooves in intricate patterns that create illusions of depth and dimension. Best seen in raking light or in person at close range, the technique inscribes a prominent tooth into these surfaces. The texture of the reliefs refers to pixilation, and translates into moiré patterns when viewed through a camera phone or on computer screens when documented. Looking at DeLucia's relief works such as

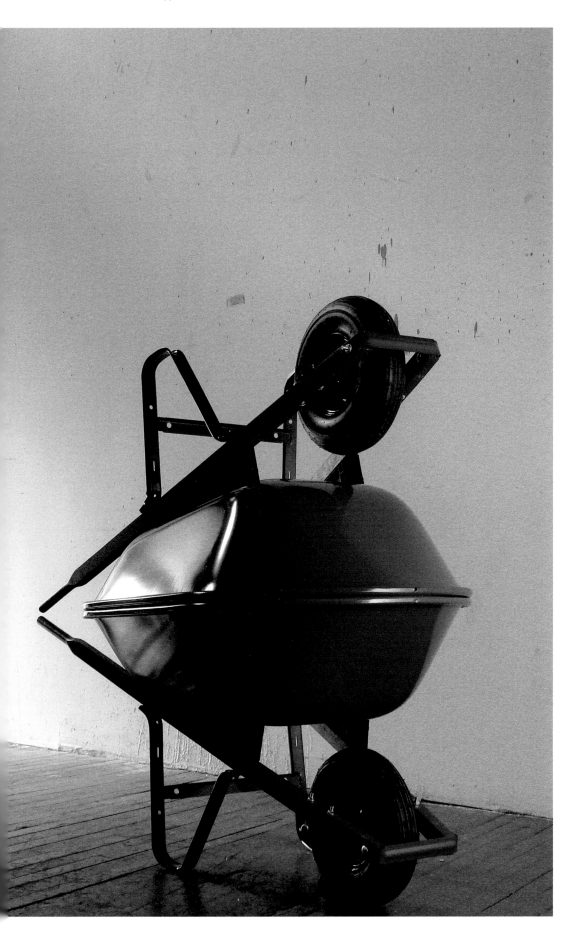

Racecar, 2009
wheelbarrows
53 × 27½ × 46 in
Collection of the Artist

Michael DeLucia

Projection (green), 2012
plywood, enamel
48 x 96 x 48 in
Vanhaerents Art Collection, Belgium

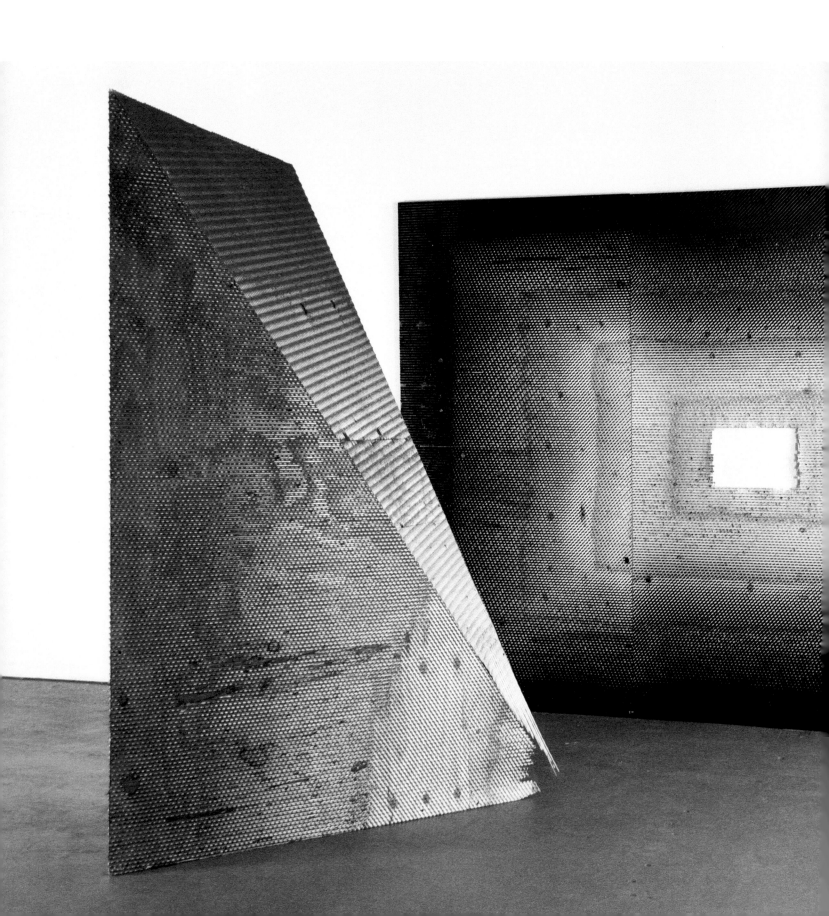

Silver Screen, 2012
plywood, safety enamel
96 x 144 x ¾ in
Vanhaerents Art Collection, Belgium

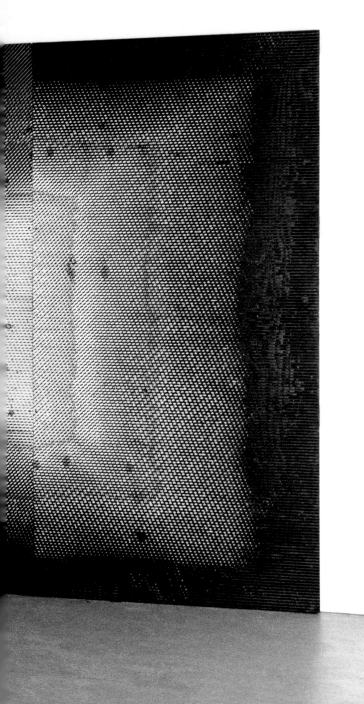

Projection (green), 2012, and *Silver Screen*, 2012, through a camera or smart phone screen, one's view is also flattened, heightening the works' illusionistic effects. The reliefs are made with this now-ubiquitous vantage point in mind at the time of their inception, and an awareness of their eventual translation into photographic documentation. The relationship between sculpture and photography is a key facet of DeLucia's practice—firmly rooted in three-dimensional form, yet always in dialog with the two-dimensional, these works imply their own circulation back into digital formats.

While this illusion of three-dimensionality is a prominent aspect of the relief works, it is also subverted, grounding us in the physical objecthood of the works in situ. The process of routing often wears down the plywood to the point that it disintegrates, revealing gaps in the pictorial space. A certain violence takes place as the virtual object is imposed onto an unrelated material. Irregularities of the support material create splinters and cracks, as each panel responds differently to the cutting process. Wheat pasted advertisement posters, often seen in urban streets, are sometimes tiled onto the wood flats before the relief patterns are engraved. These backgrounds also disrupt the illusion of the geometric forms. Their effect, similar to tiling on older websites or desktop image display options, breaks up the seamless background plane, competing with the foreground layer. Employing these seemingly unrelated images plays with the tension between the abstracted context of the art gallery and everyday life.

Using plywood and paint as the most basic construction materials, these works combine rough-hewn and high-tech aesthetics. Often monochromatic, the relief works are first coated with highly visible 'safety enamel' in colors found in CAD interfaces or a hardhat site. The reliefs lie between the handmade and the digitally produced, as the CNC router's robotic arm stands in for the artist's own. The resulting, large-scale pieces possess a certain physicality; they seem to be equally at home in a white-cube gallery as they would on a construction zone. Further engaging with the legacy of Minimalism, DeLucia's practice also offers

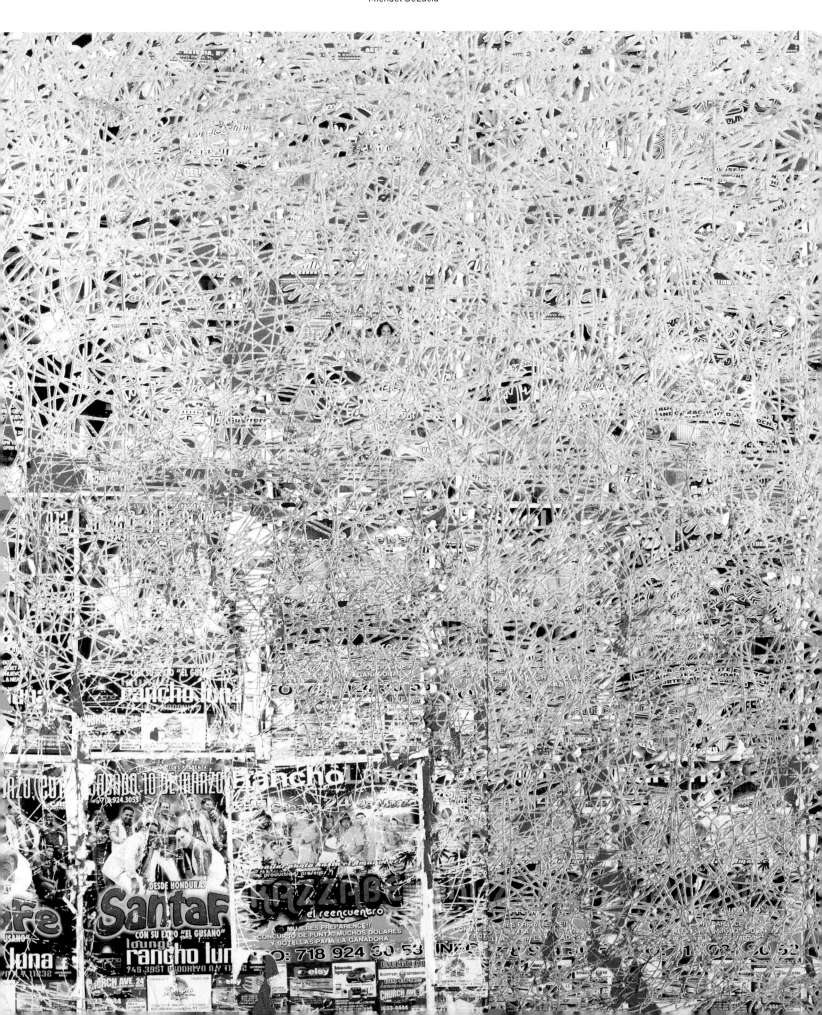

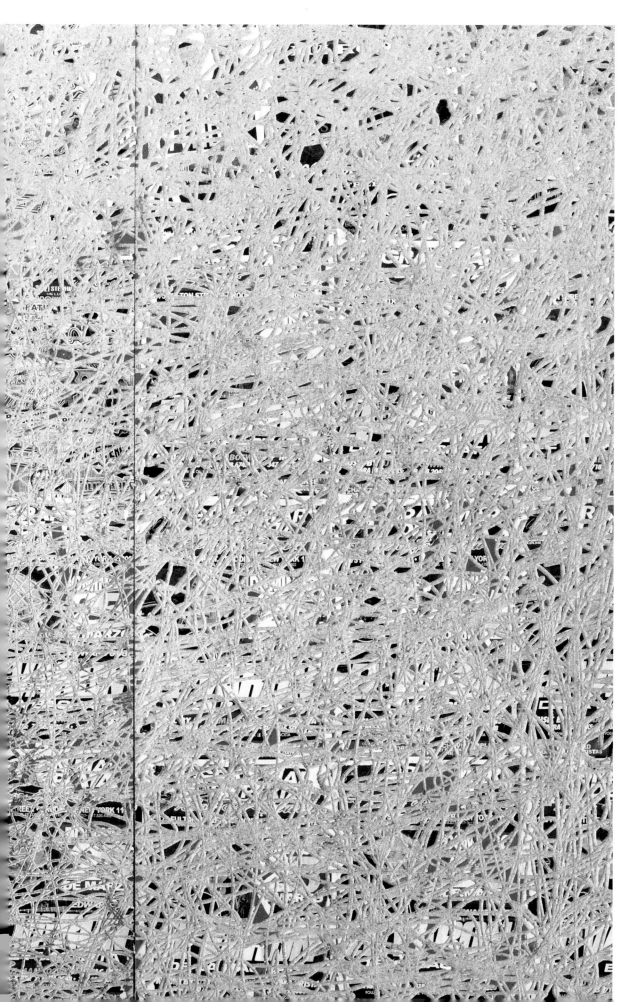

*The Time Space
Continuum,* 2012
plywood, found posters
144 × 96 × ¾ in
Zabludowicz Collection,
UK

from left to right
Cube (red/black), 2011
OSB, safety enamel
96 × 96 × ¾ in
Private Collection

a notion of sculptural phenomenology that sets up new types of subject-object relations. The online project *Artifacts*, 2011–2012, allows viewers to interact with forms in a simulated three-dimensional space. *Artifacts* consists of four digital models of geometric shapes generated by CAD software, available for download as PDF files. The interactive three-dimensional forms can be enlarged, reduced, and circumnavigated—offering an altered encounter with sculpture, while simultaneously exposing a step in the process by which DeLucia creates his large-scale physical objects. The images change and come in and out of view, depending on our vantage point within the three-dimensional space. The models pose problems for the display adaptor and appear overlaid or collapsed onto themselves, as the computer attempts to reconcile the spatial rendering. This work offers a radically different encounter between the viewing subject and sculptural object, one that simulates the experience of circling sculpture in physical space. When viewing virtual objects on a computer screen, not only is the physical experience in space removed, the body is in fact hampered in its potential motion. It remains relatively still, restricted to minor movements of the hand. The forms and surfaces of DeLucia's digital sculptures are explored with the eyes alone, disassociated from the rest of the body in abstract, illusionistic space. While there is a loss of viscerality in this contemporary scenario, the situation simultaneously extends the human body's capability of interacting with sculpture in physical space, allowing us to permeate or hover above the three-dimensional modeled objects.

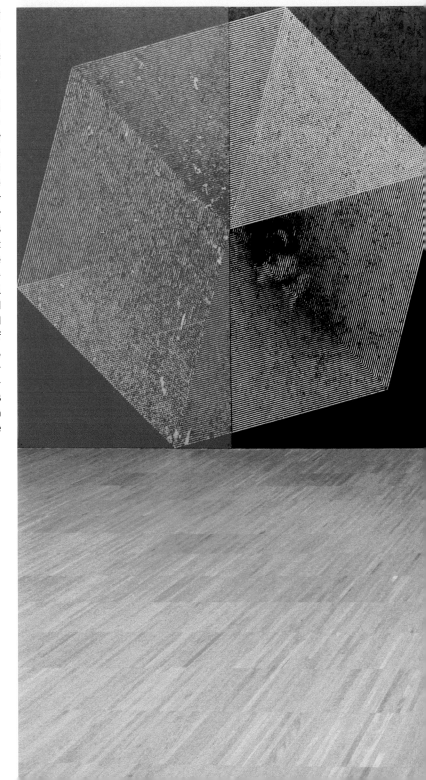

Cube (black/blue), 2011
OSB, safety enamel
96 × 96 × ¾ in
Private Collection

Cube (blue/orange), 2011
OSB, safety enamel
96 × 96 × ¾ in
Private Collection

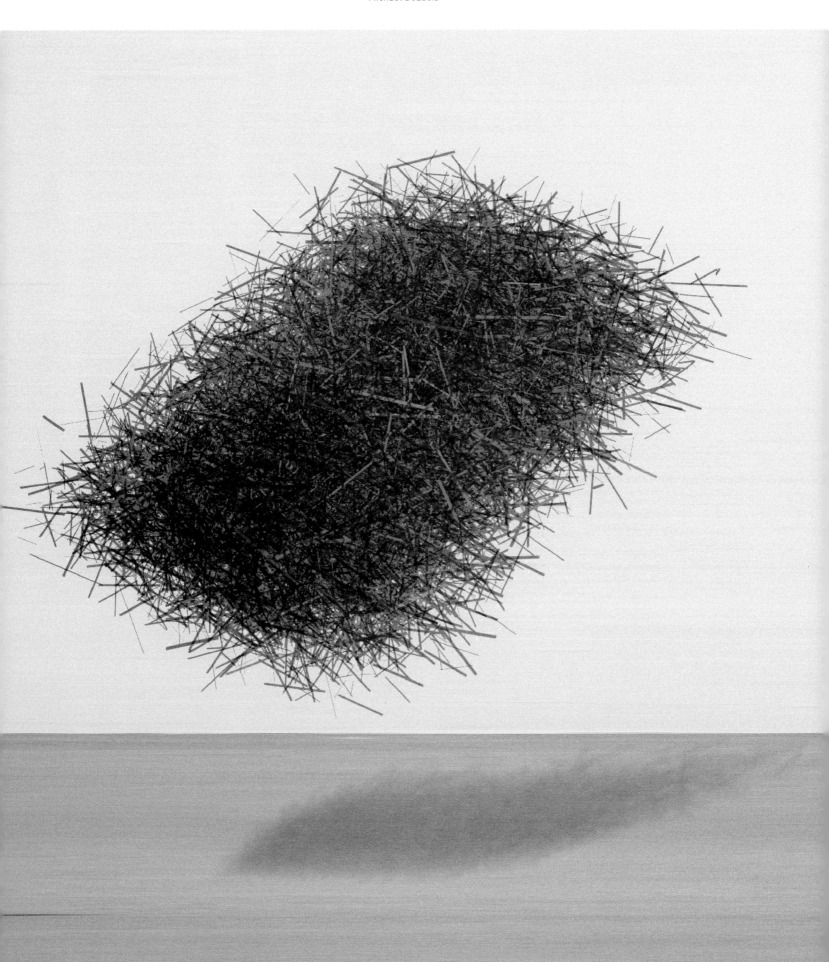

opposite
Bail (from *Artifacts*), 2007
digital rendering of 3D model
Collection of the Artist

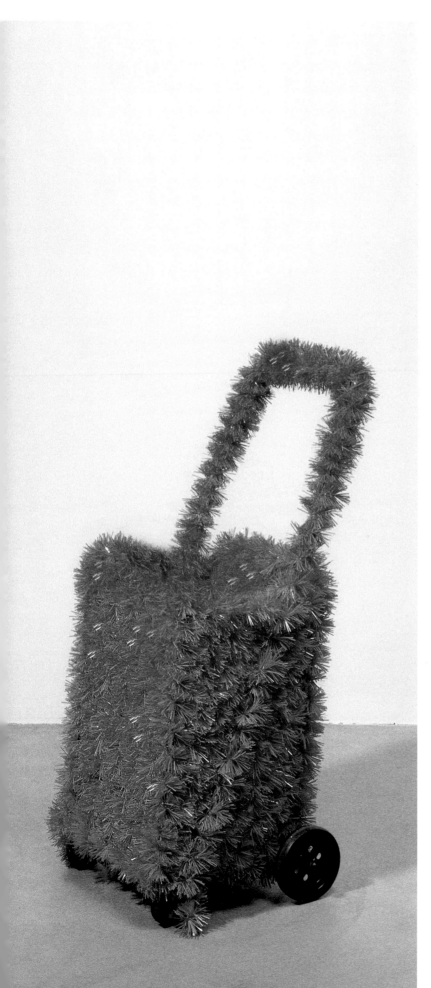

left
Transcendental Object, 2008
grocery cart, tinsel garland
38 × 11½ × 12½ in
Collection of the Artist
Courtesy of Galerie Nathalie Obadia

Switching between two and three dimensions and mapping data onto different mediums in physical and digital space, Michael DeLucia's practice engages with the problems and advantages of translation, grappling with the possibilities of truly 'knowing' a form or object. His works also speak to navigating virtual space as an increasingly recurrent activity, questioning how our relationship to sculpture and digital objects has and will change with the mediation of such technologies. It prompts queries into the nature of our current and future engagements with the world and the objects in it based on these relatively new encounters. When we step away from the computer screen, do these new forms and experiences remain as afterimages? Does our more frequent contact with the world from a passive position represent a lost visceral connection between objects in space and our physical bodies, or does this condition promise greater understanding, enhancing the potential of our biological technology? Could more habitual explorations of three-dimensional form in illusionistic, virtual space advance our practice of vision and imagination, possibly improving our ability to navigate our internal worlds from a more meditative position? Can our capacity to recall and explore memories, inventions, or visions become more sophisticated—do such activities constitute a form of exercise or training of the mind's eye? DeLucia's manifold investigations seem to gesture toward such trajectories. If the spectacular is not offered up in the mundanity of city-dwelling routines, can we hope to achieve a more wondrous interior life?

WORKS 2006 – 2015

Michael DeLucia

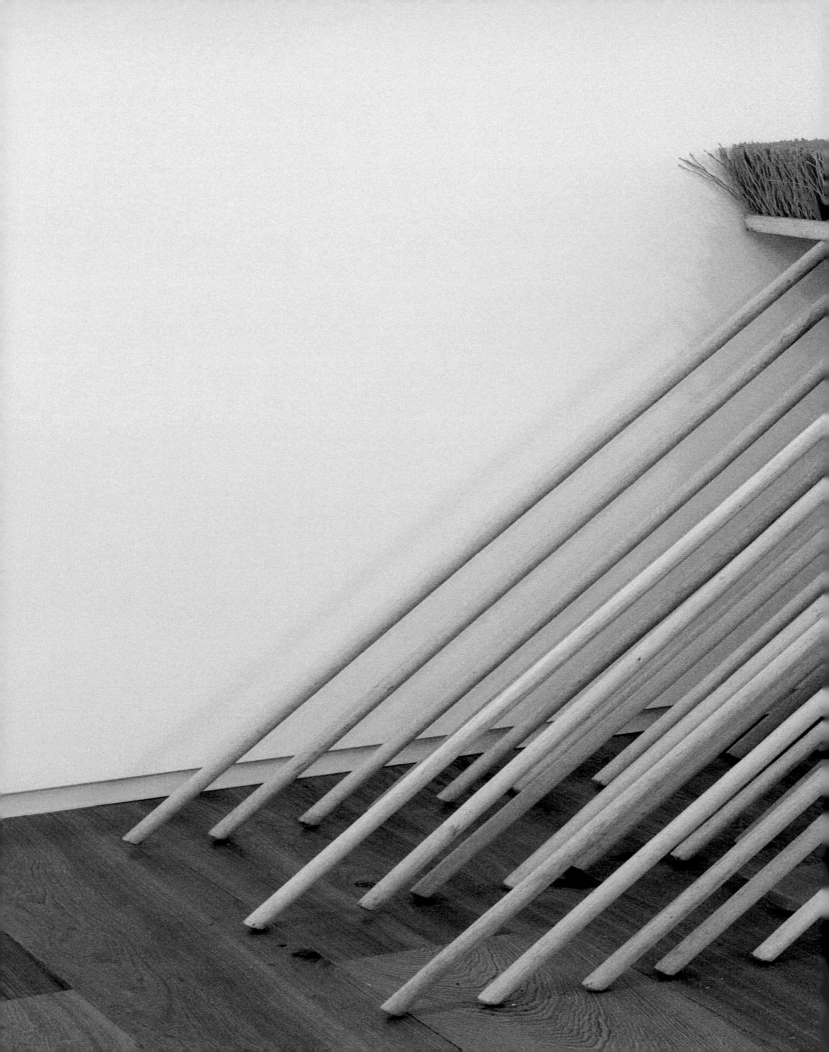

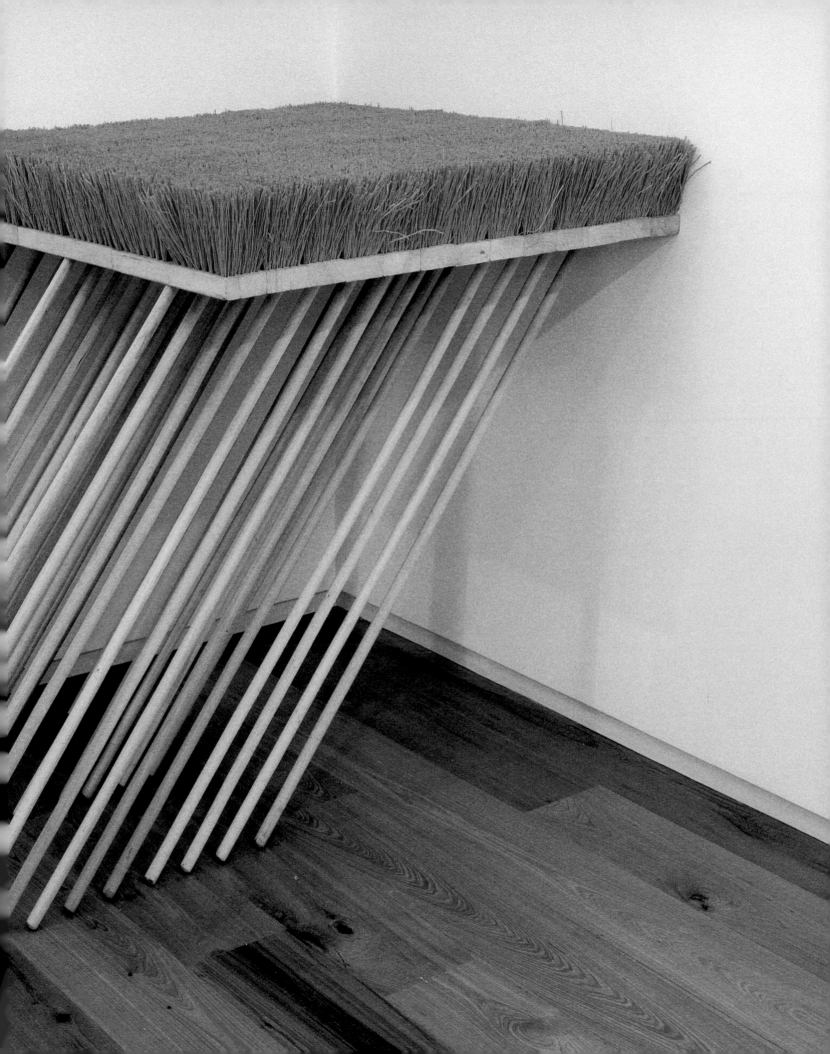

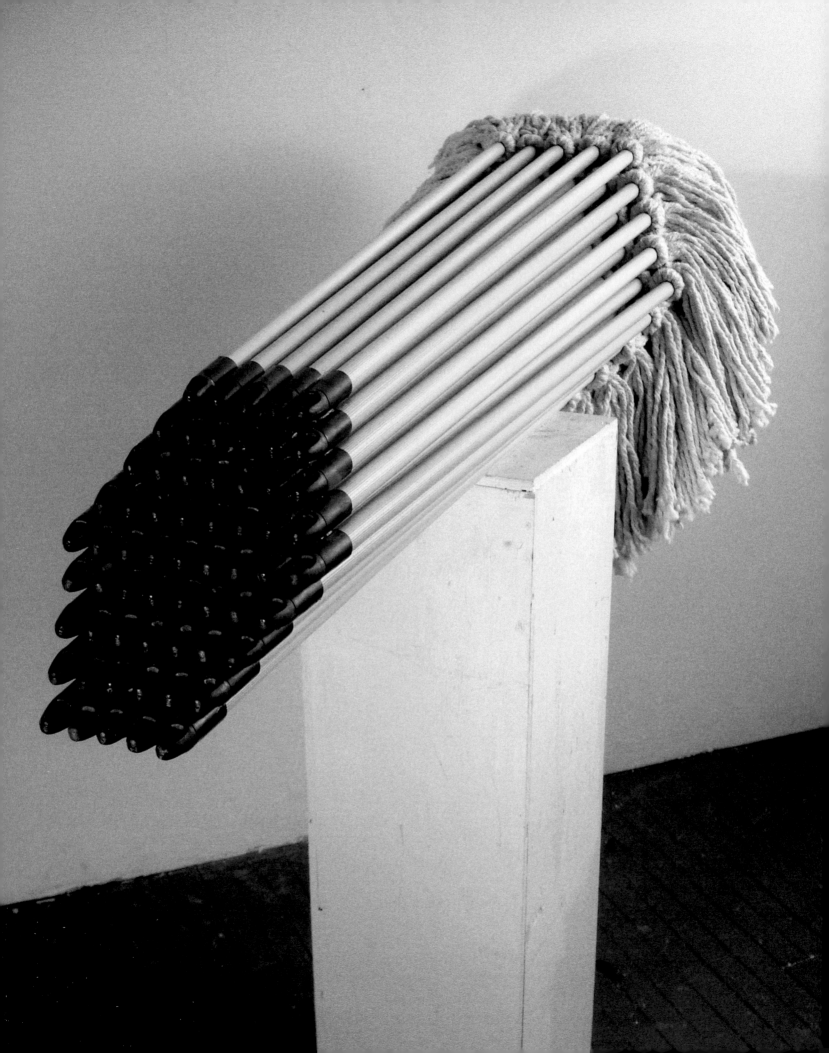

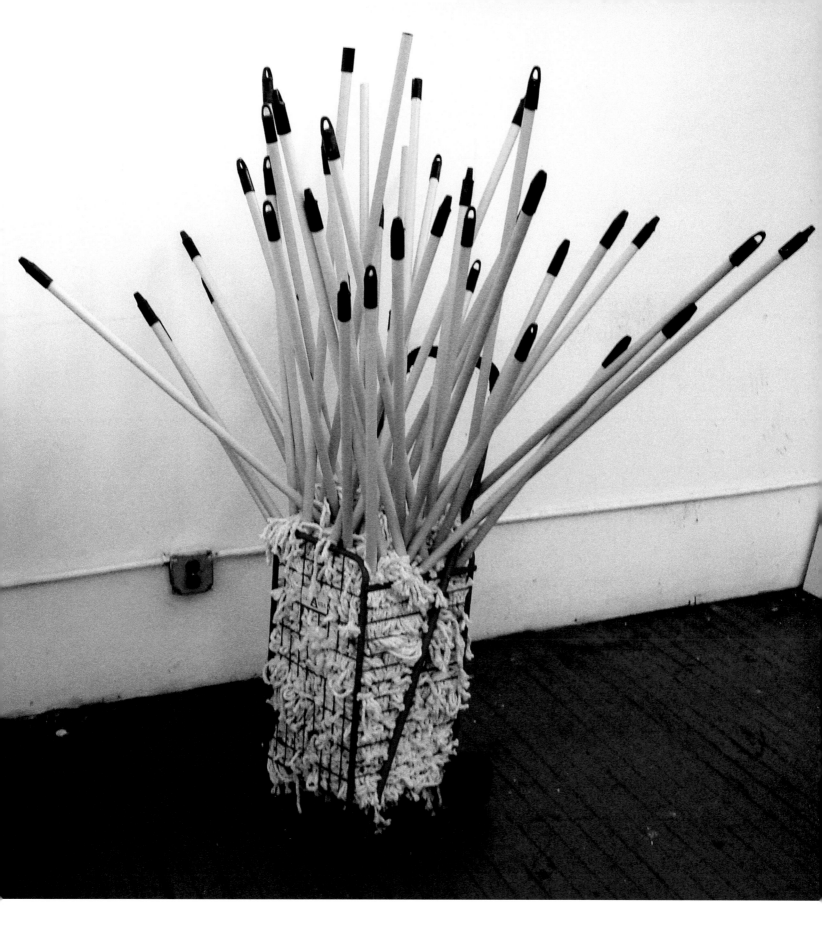

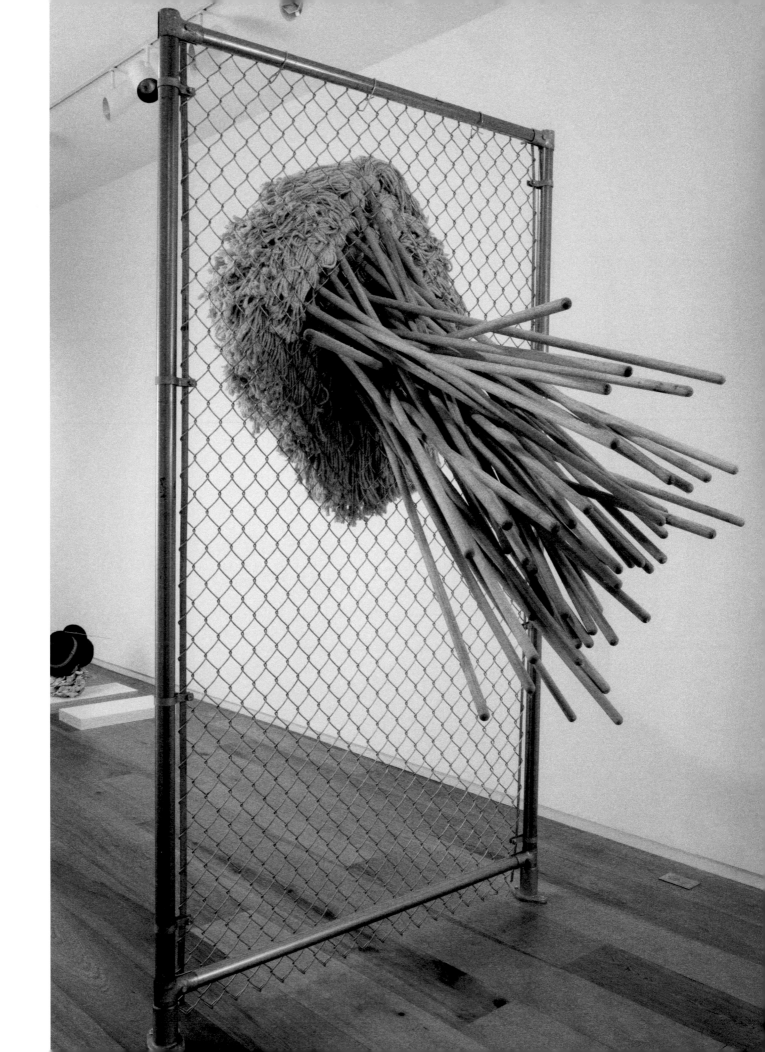

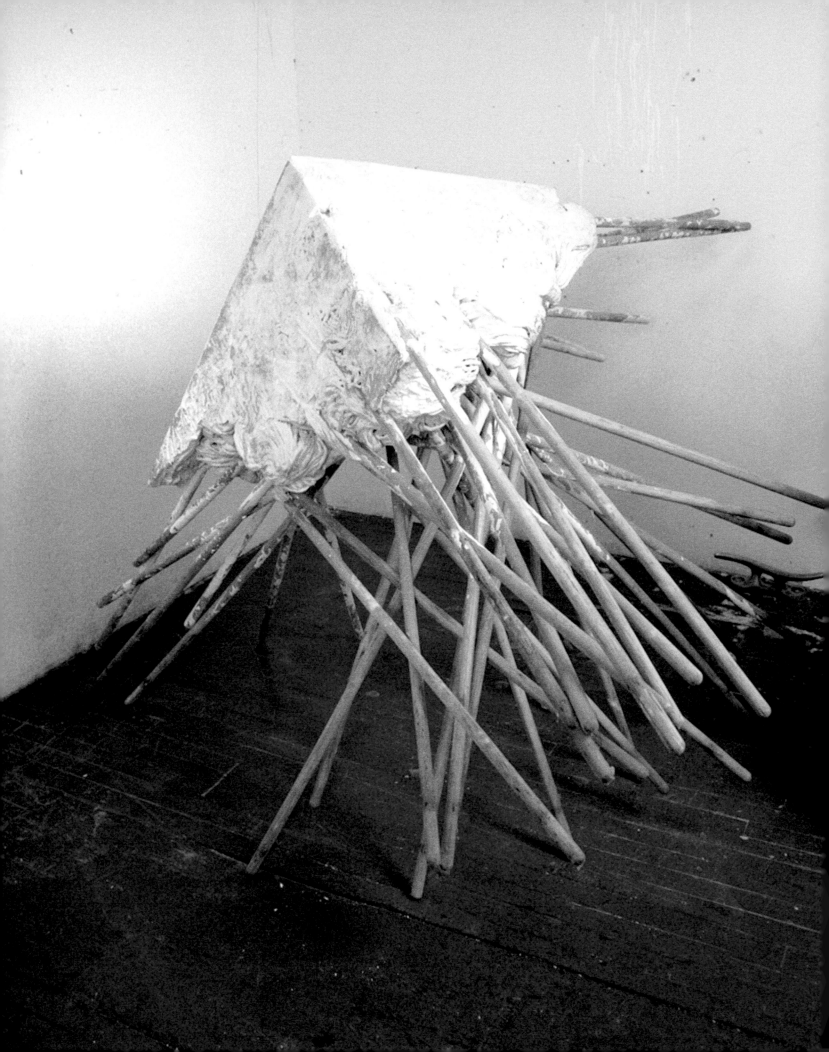

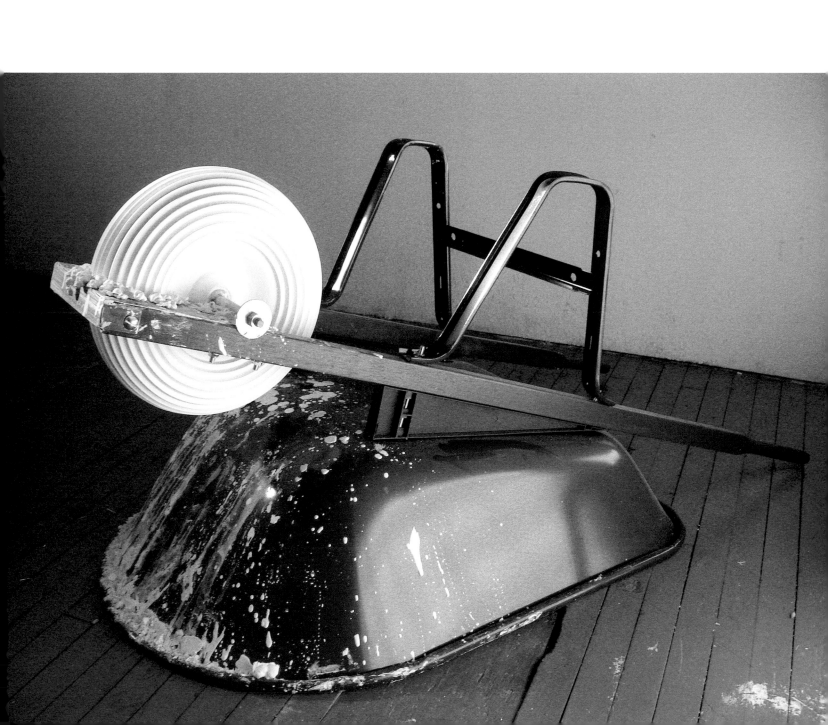

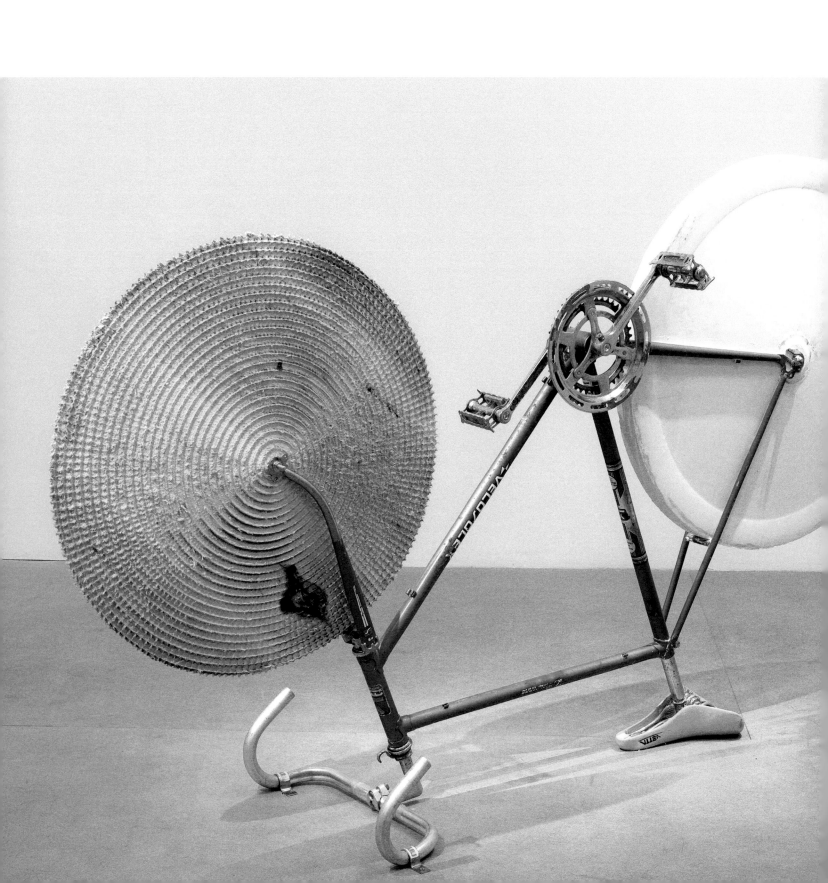

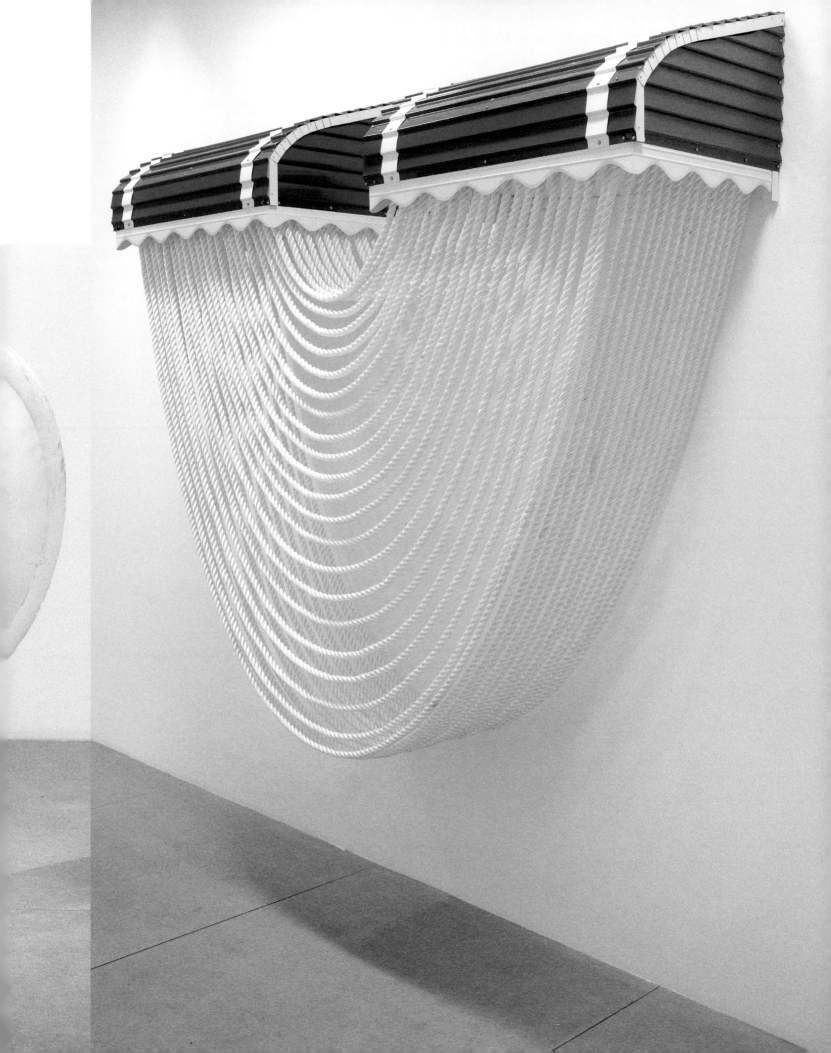

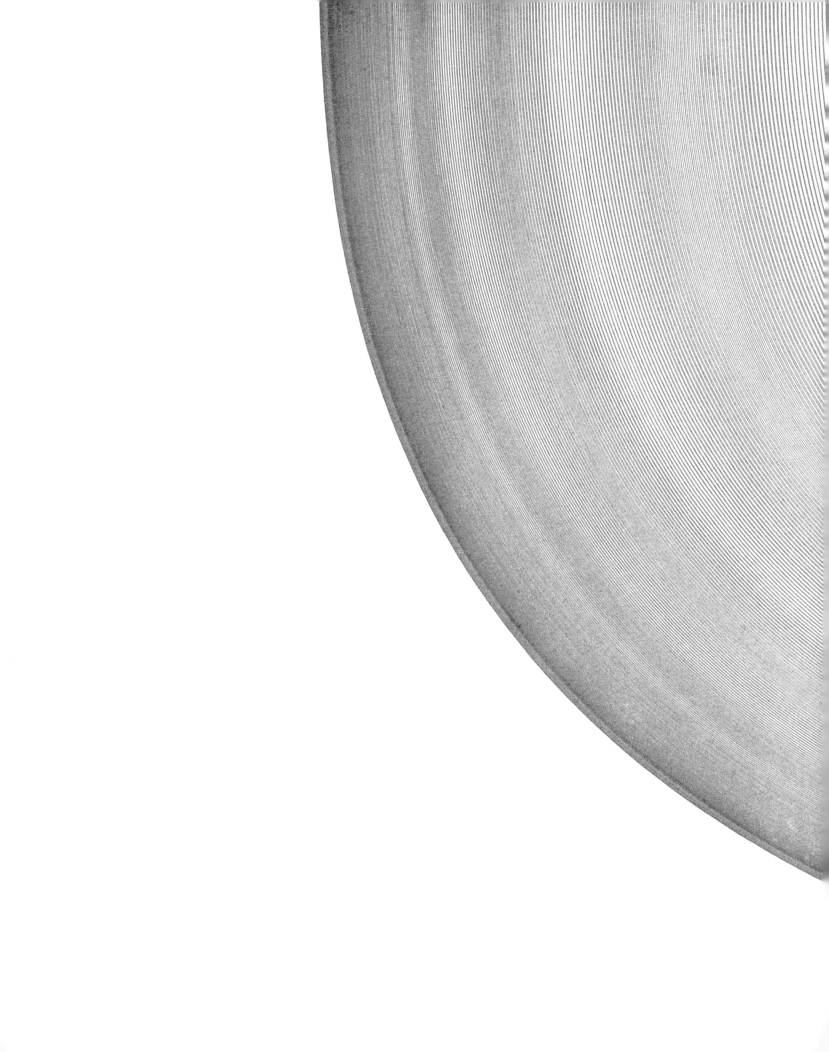

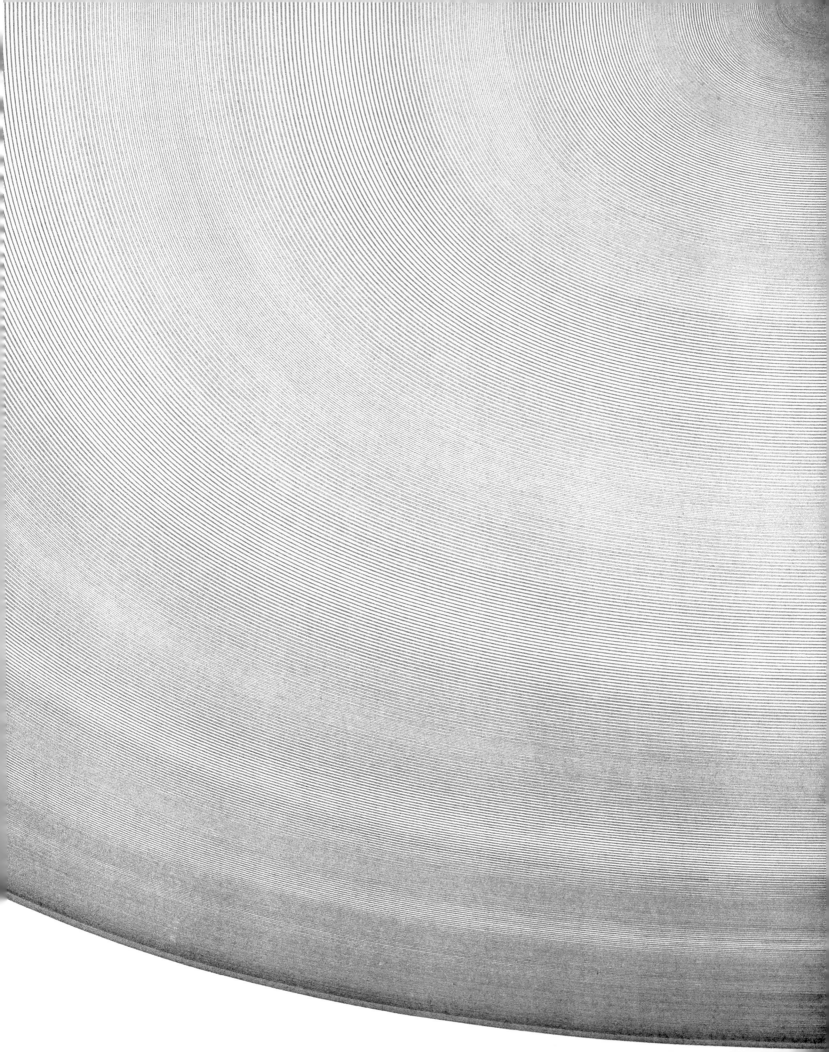

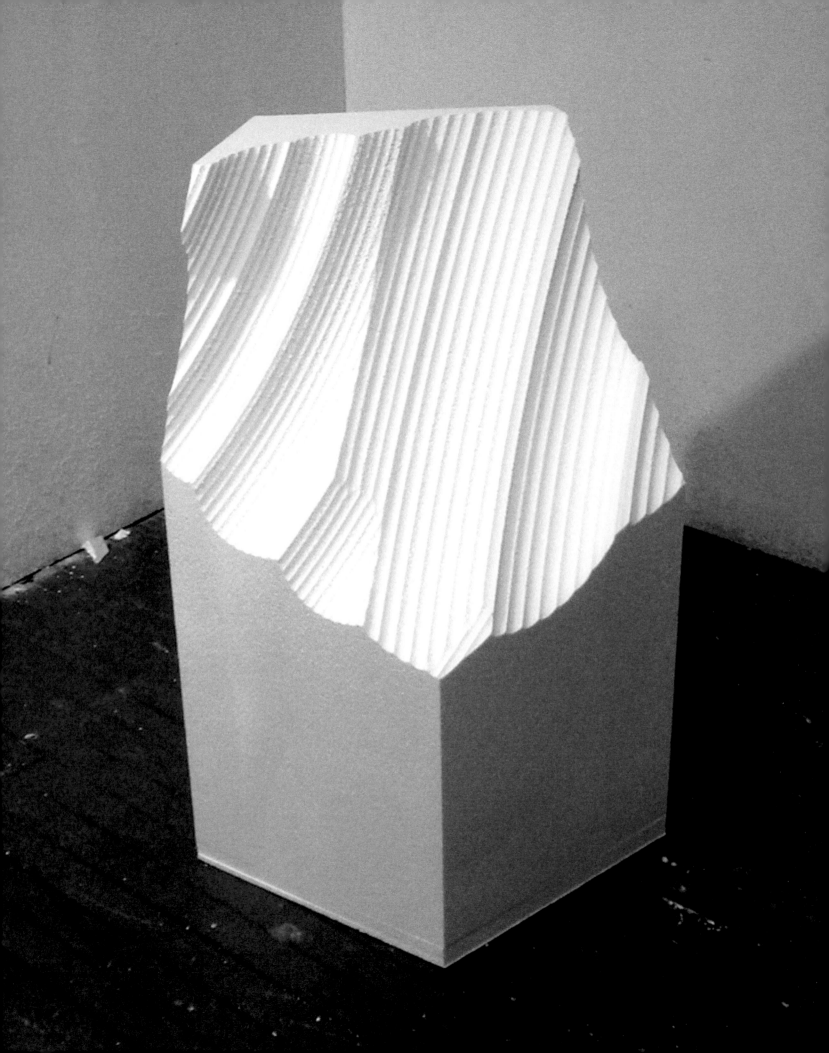

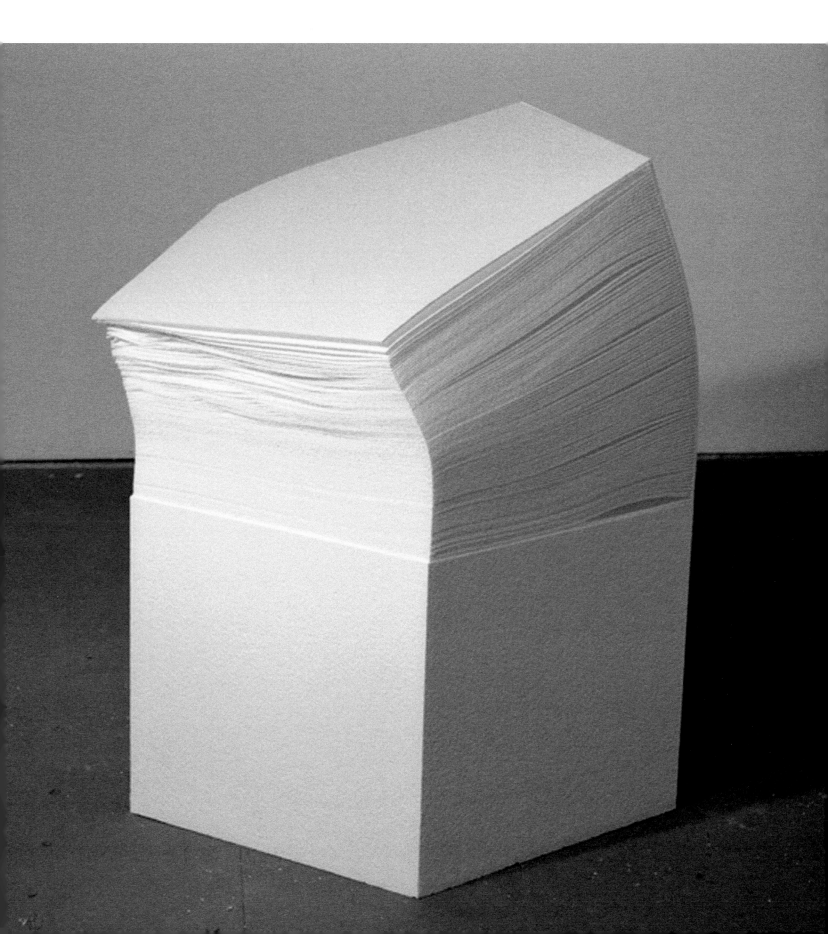

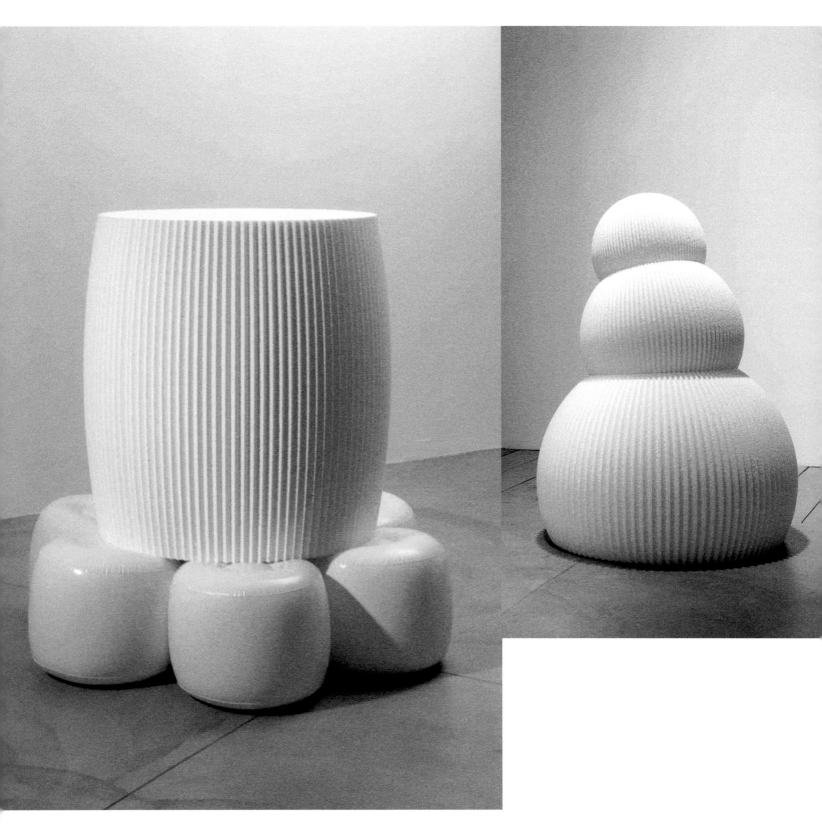

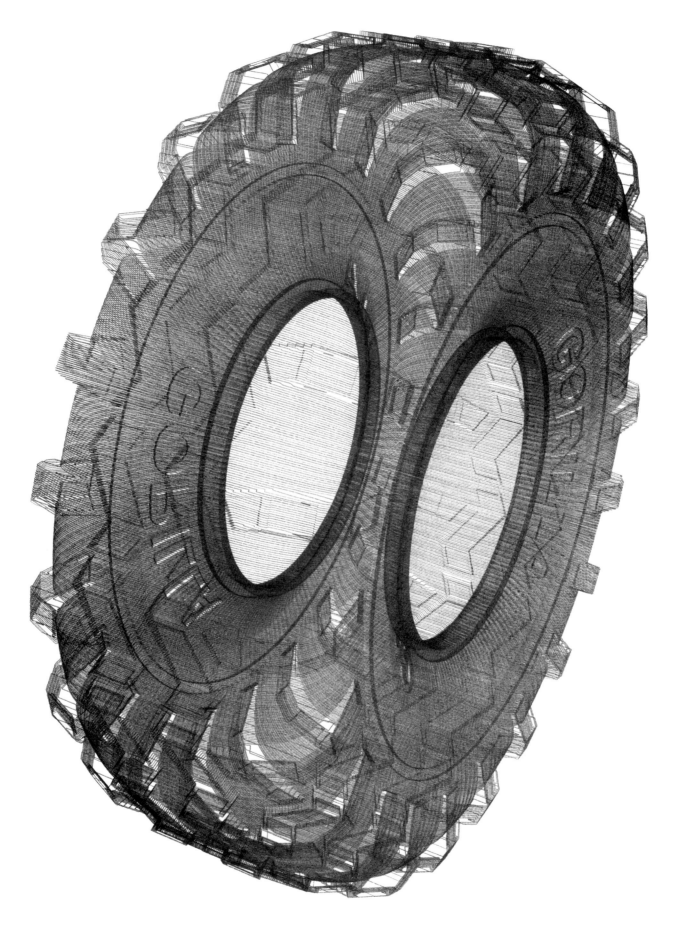

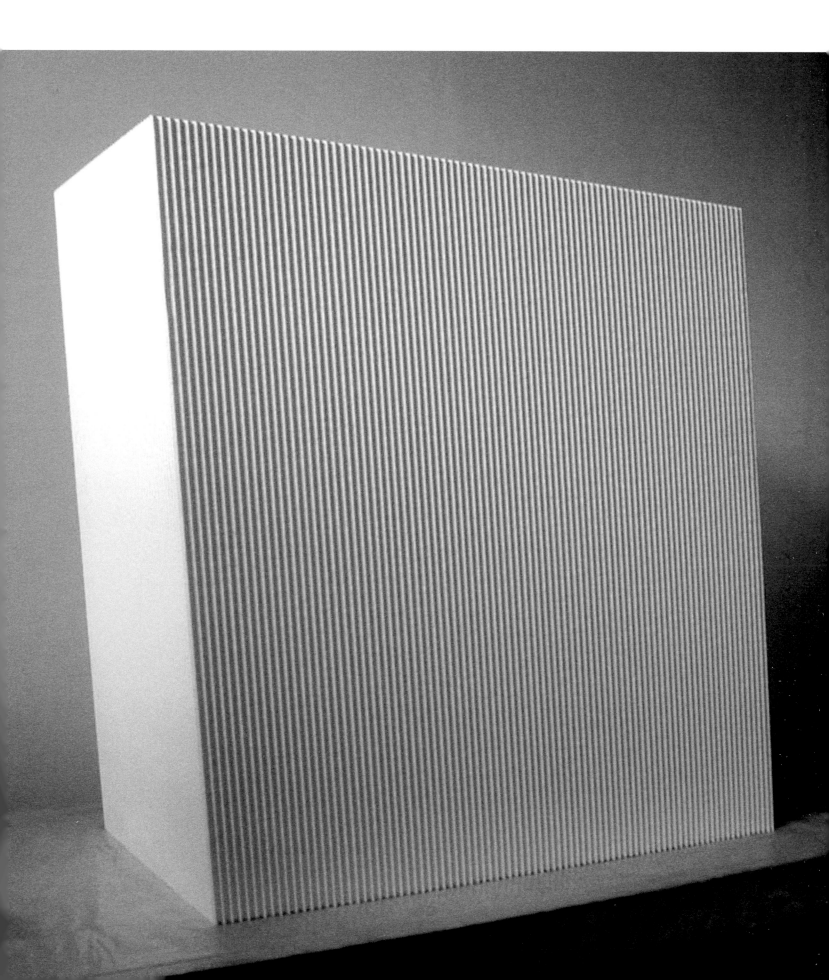

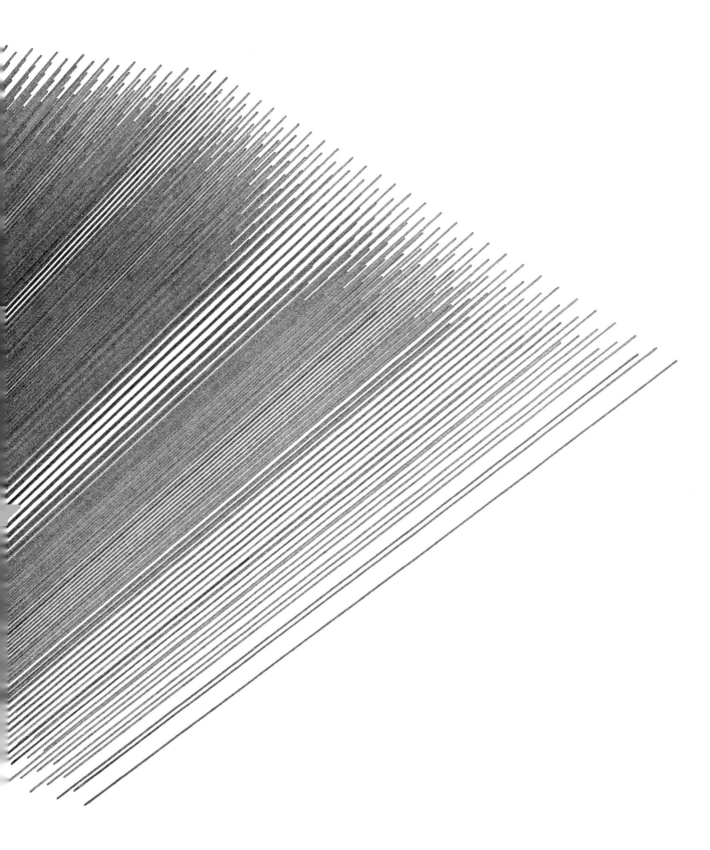

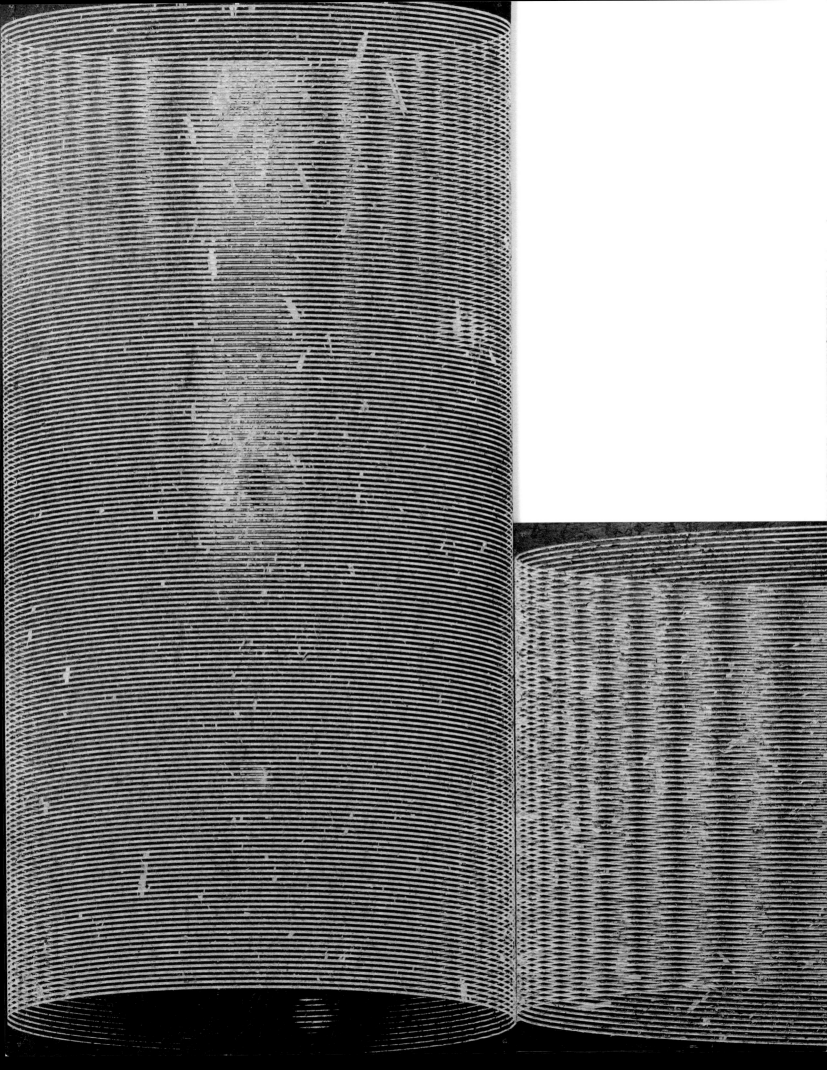

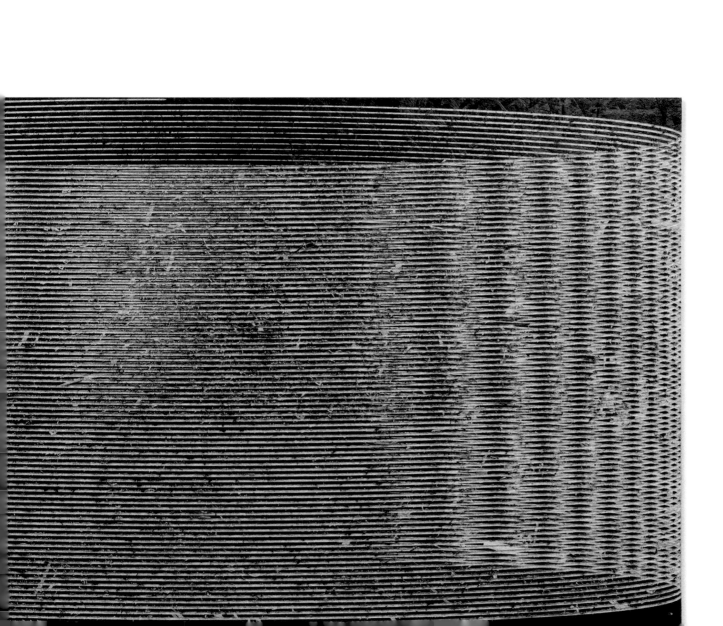

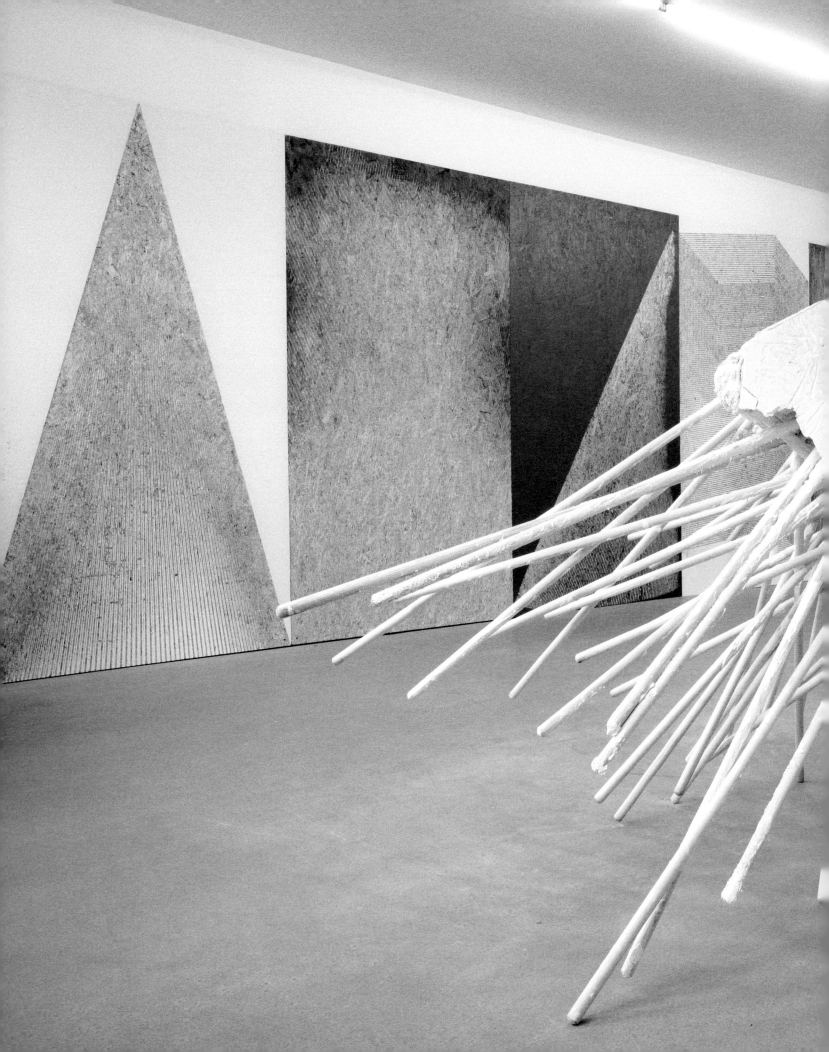

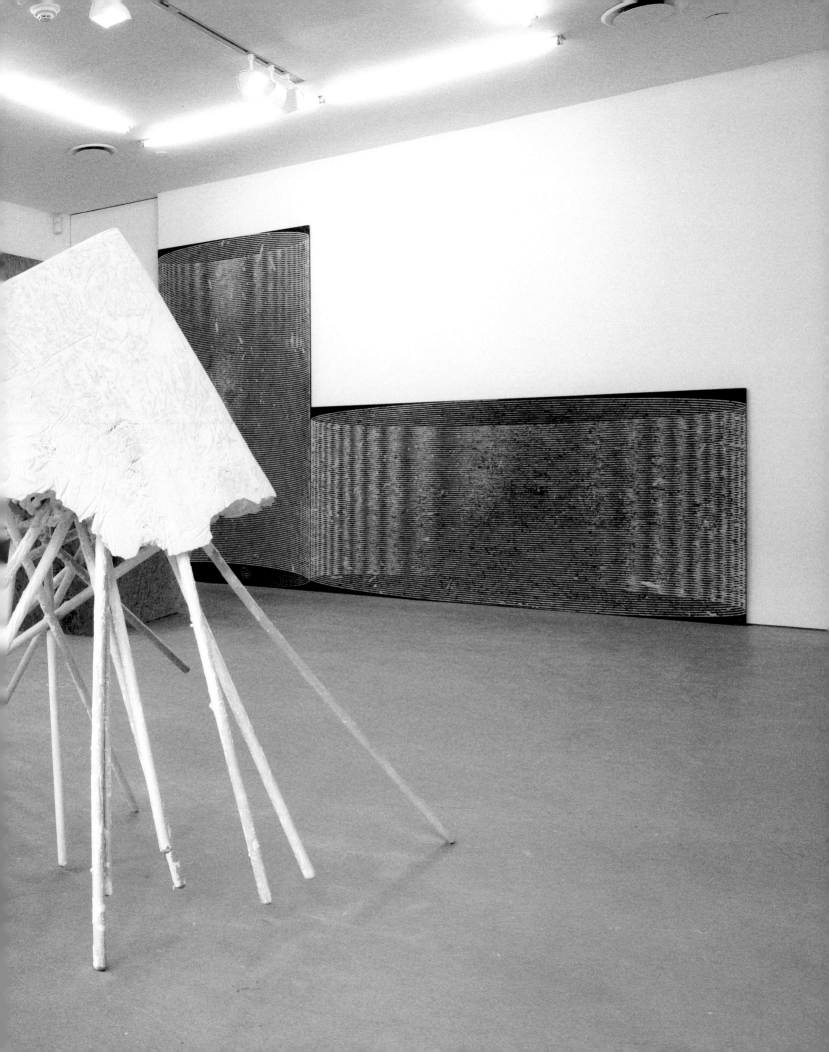

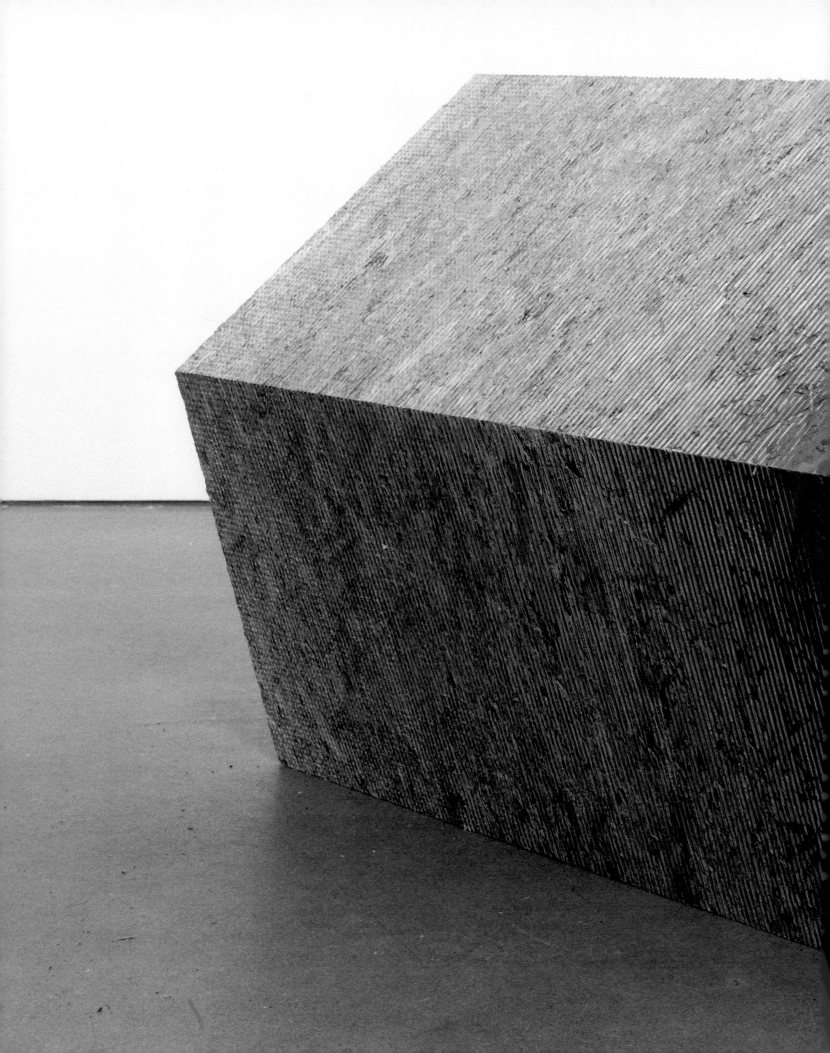

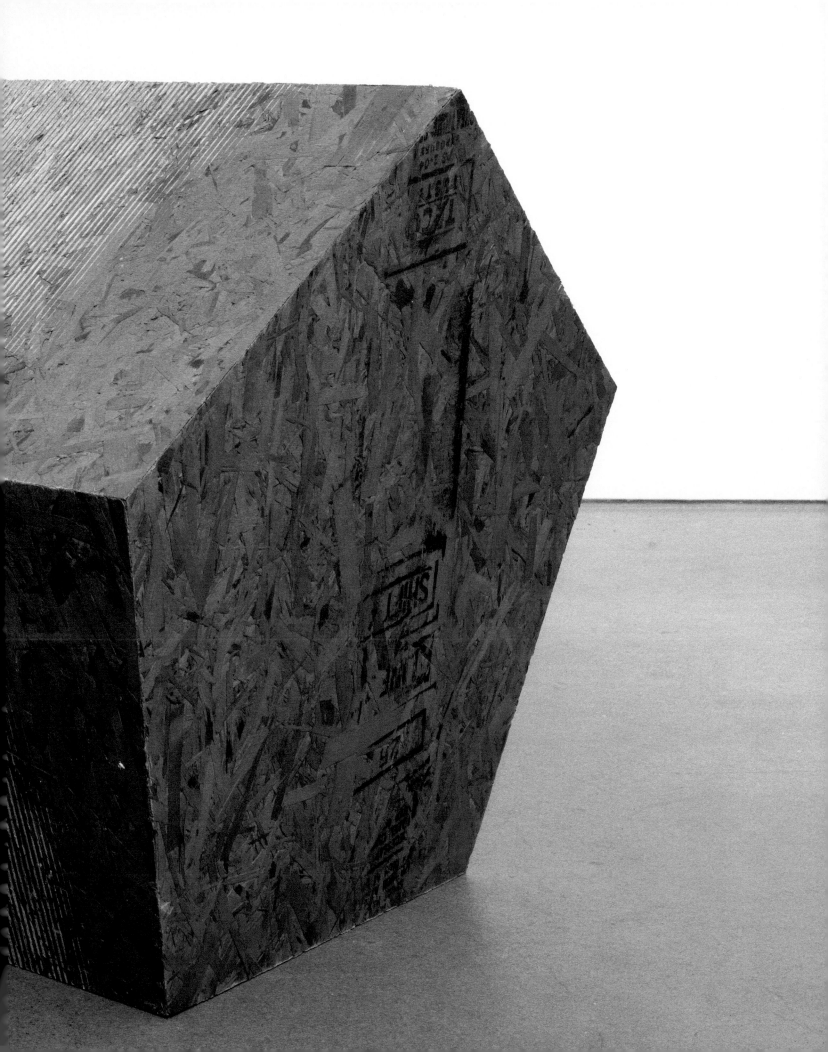

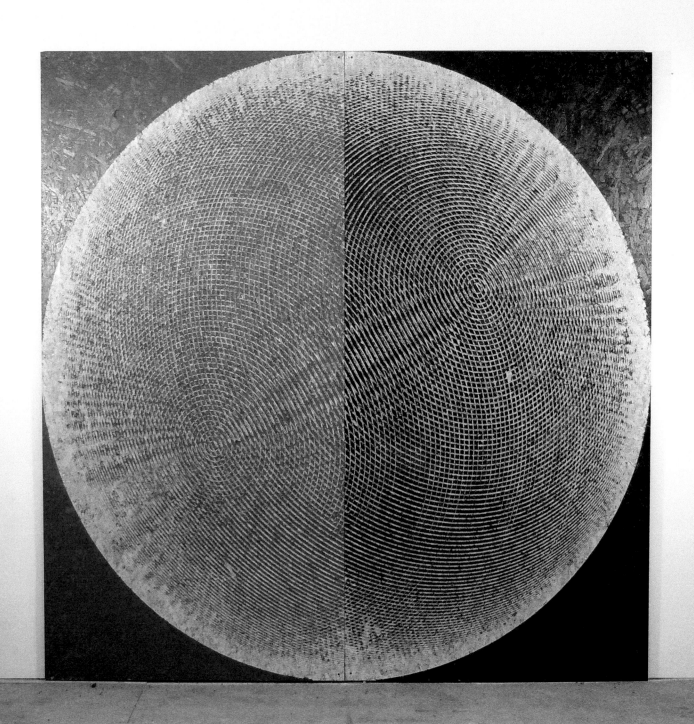

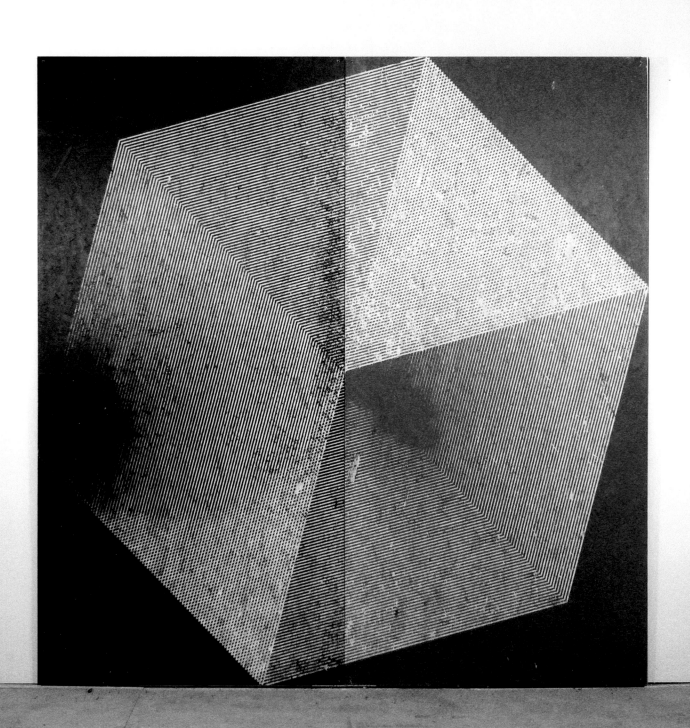

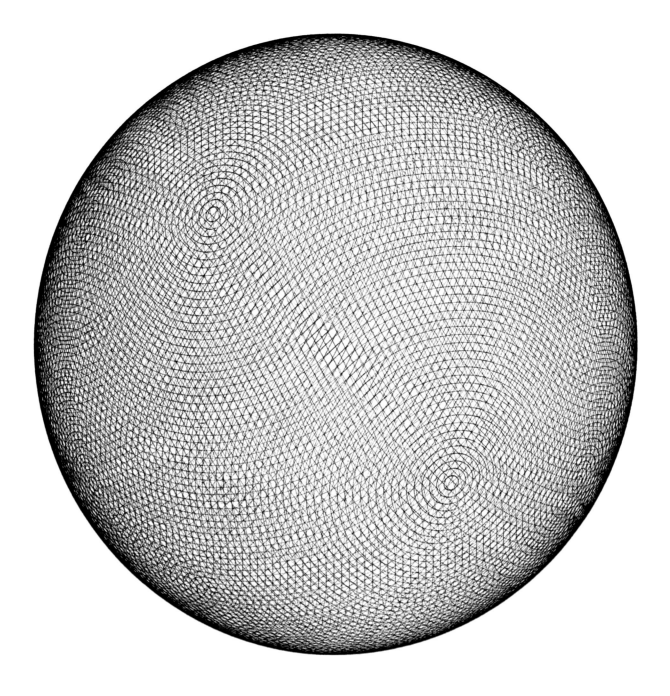

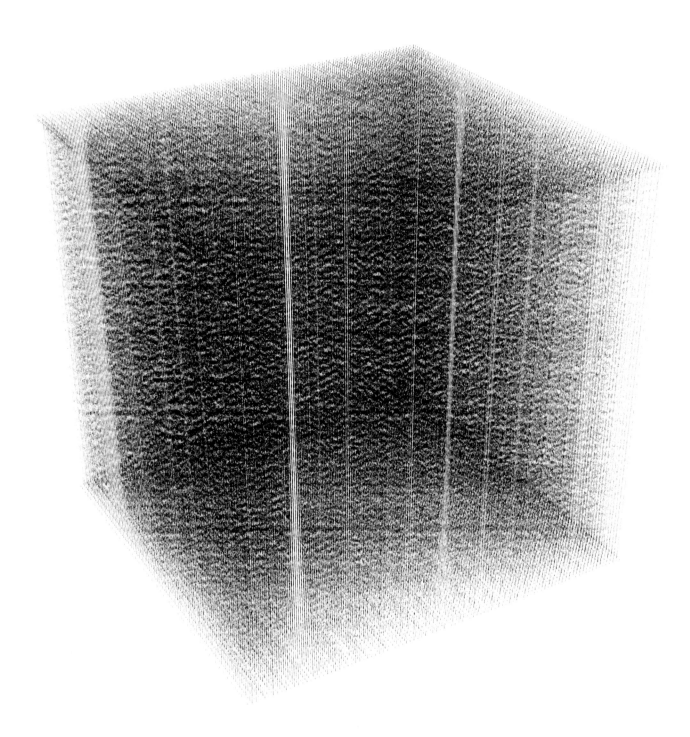

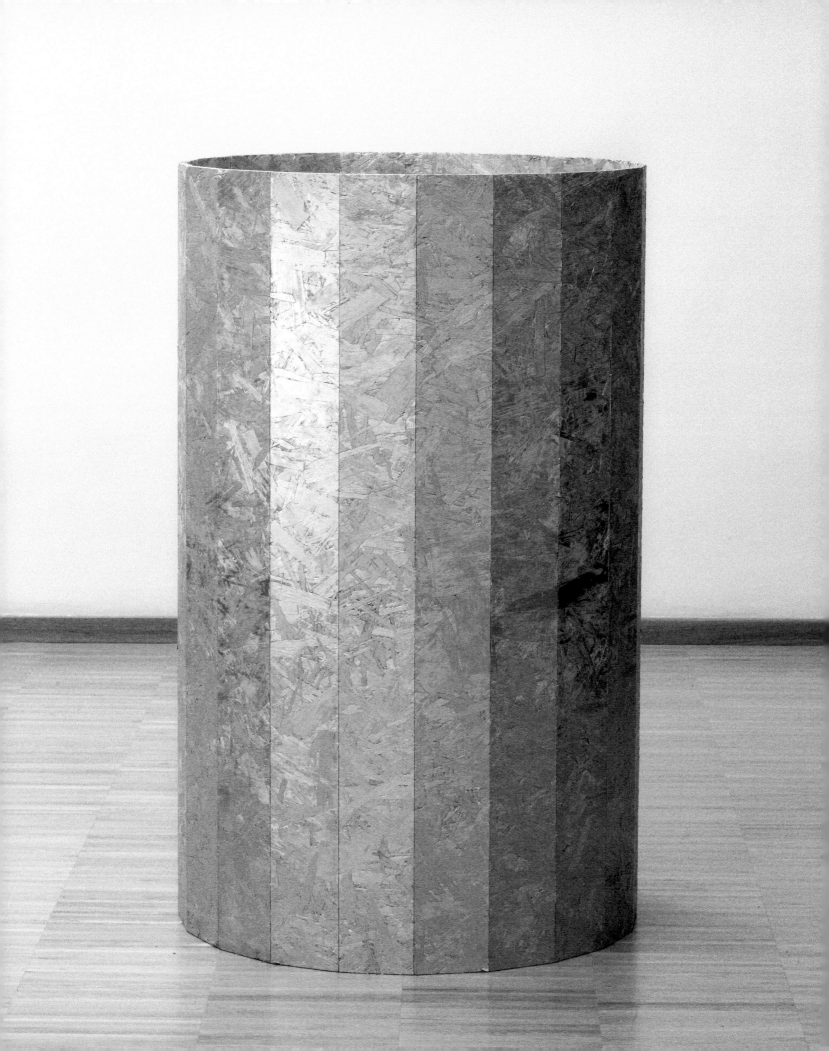

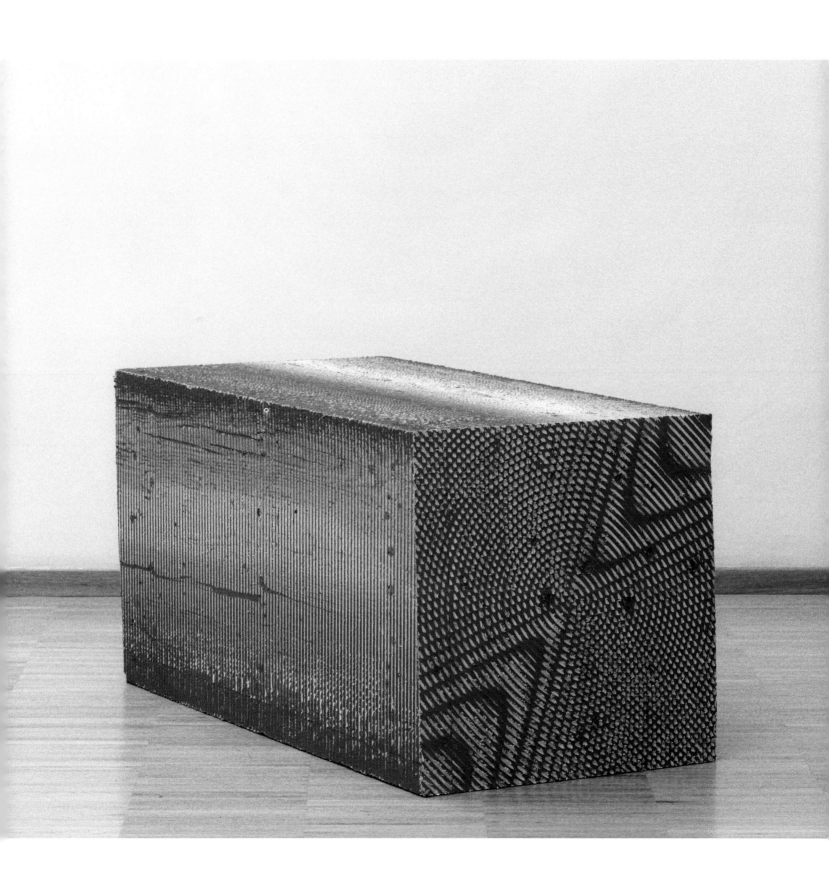

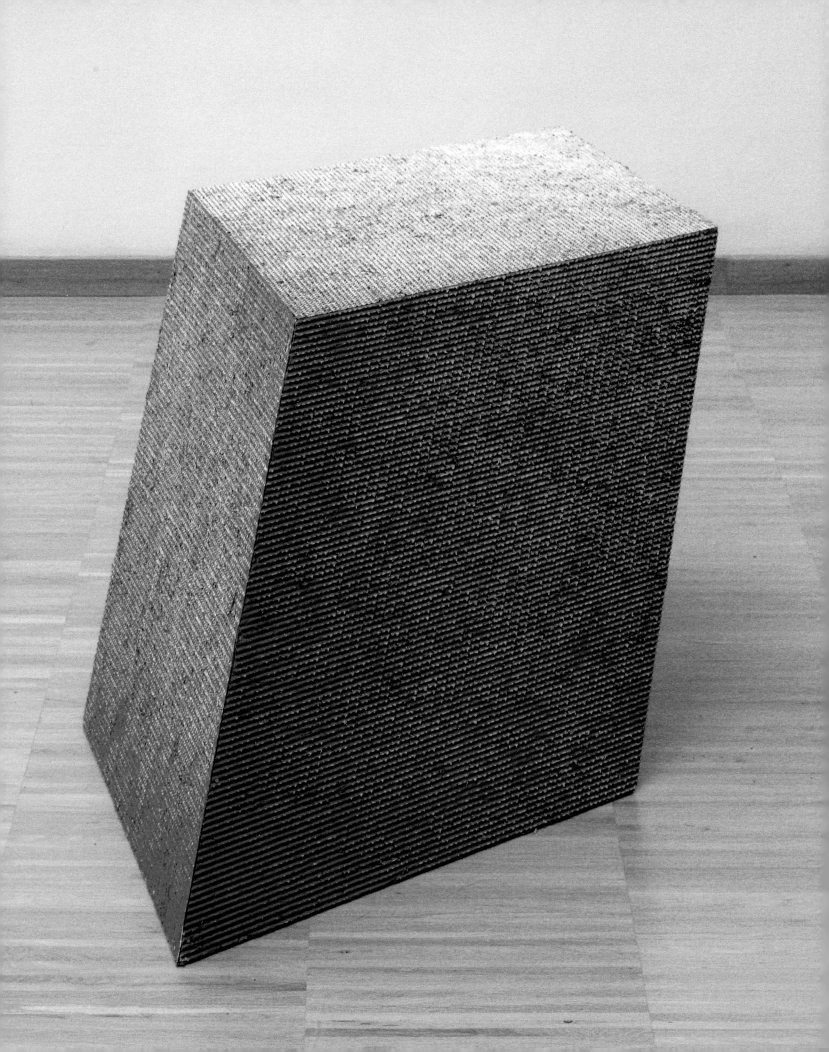

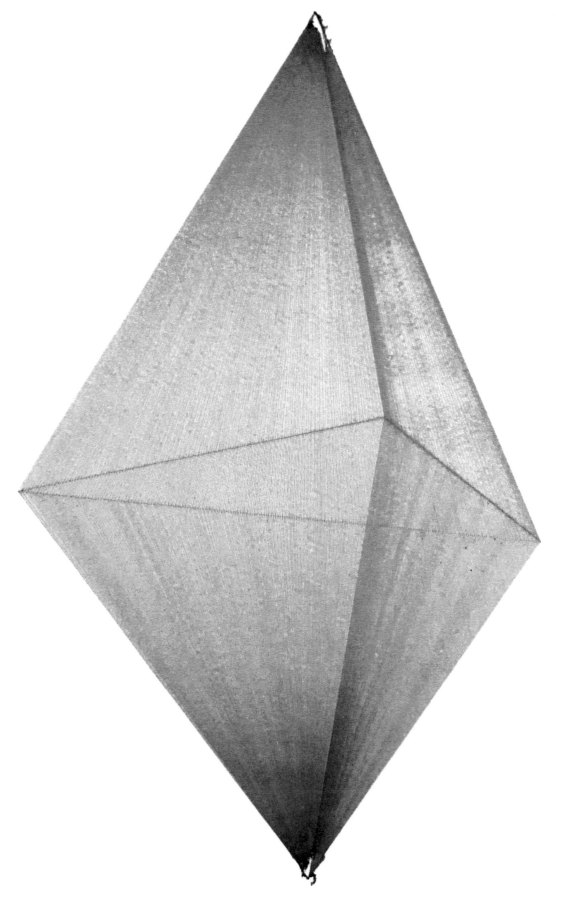

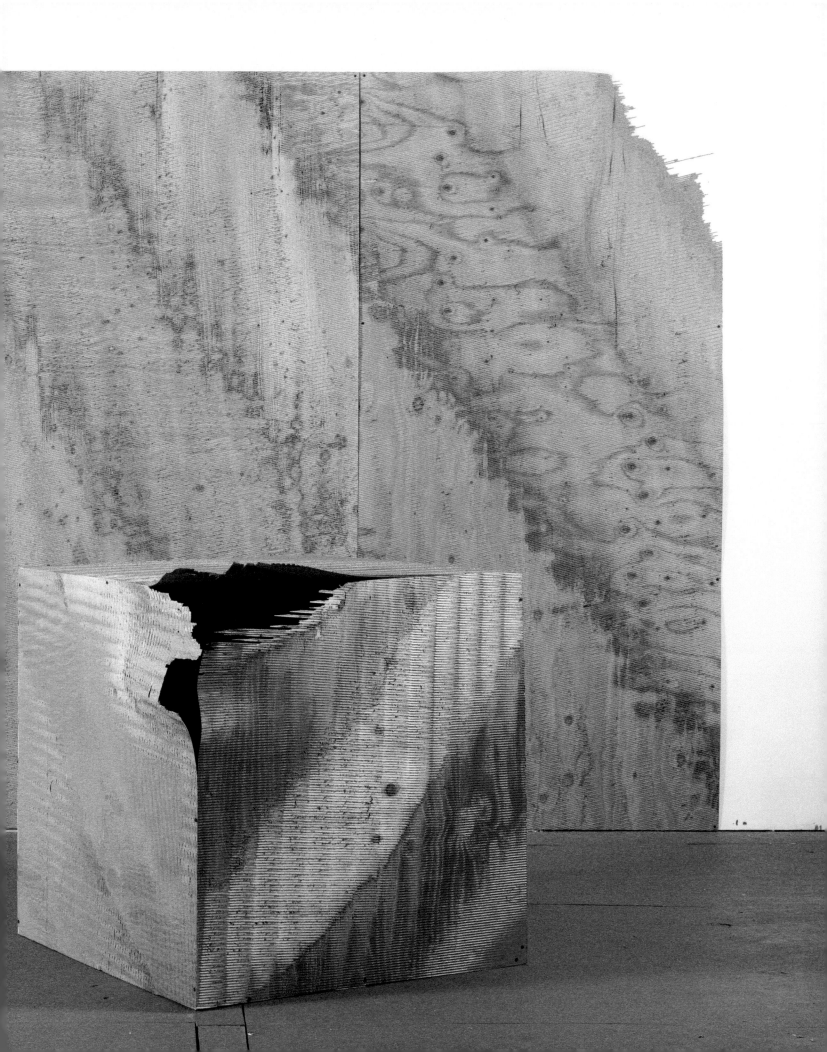

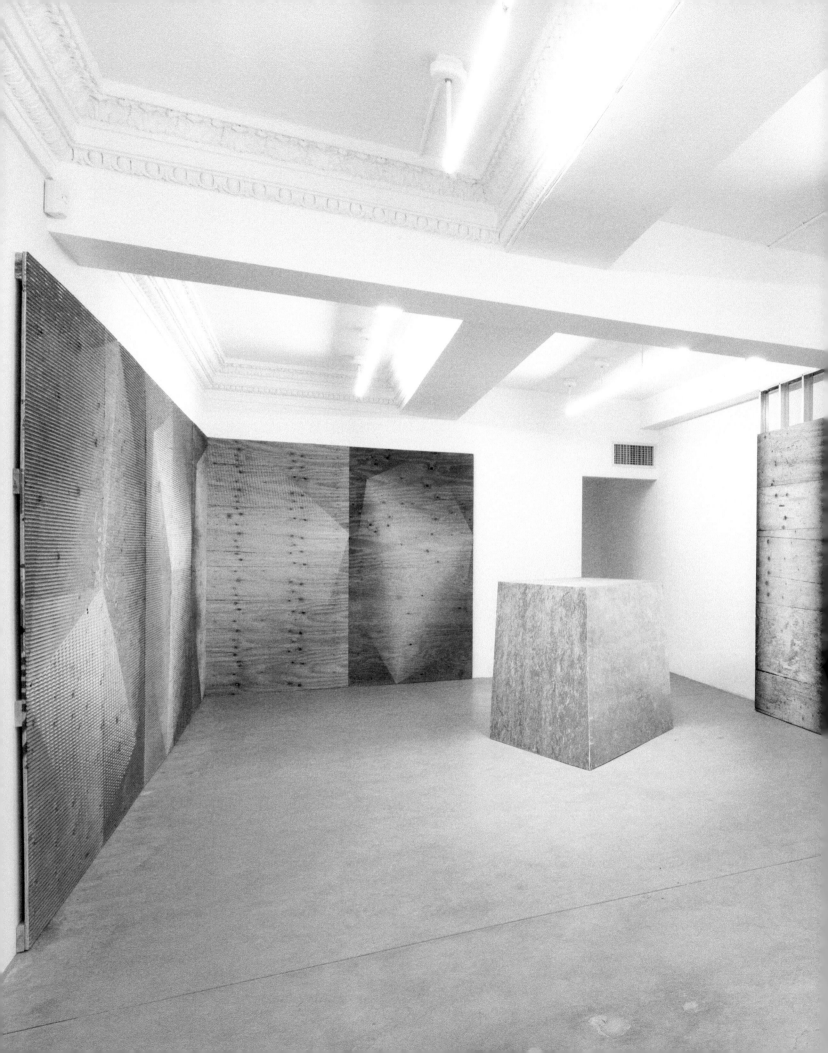

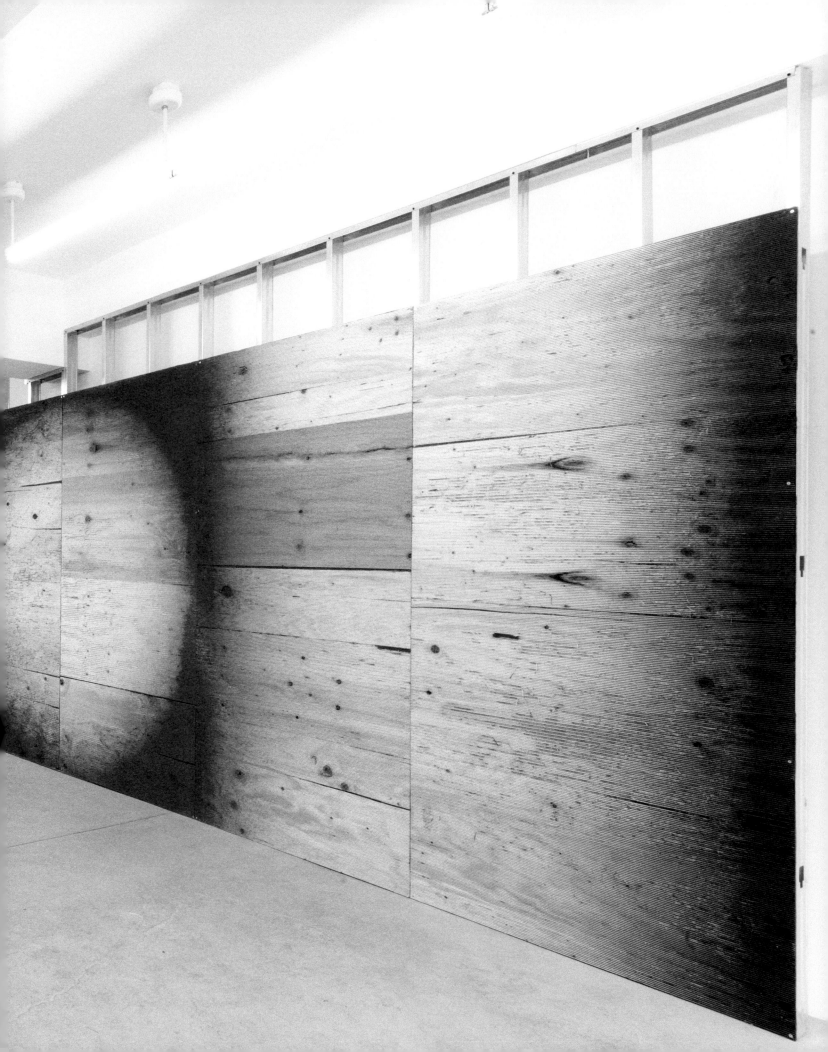

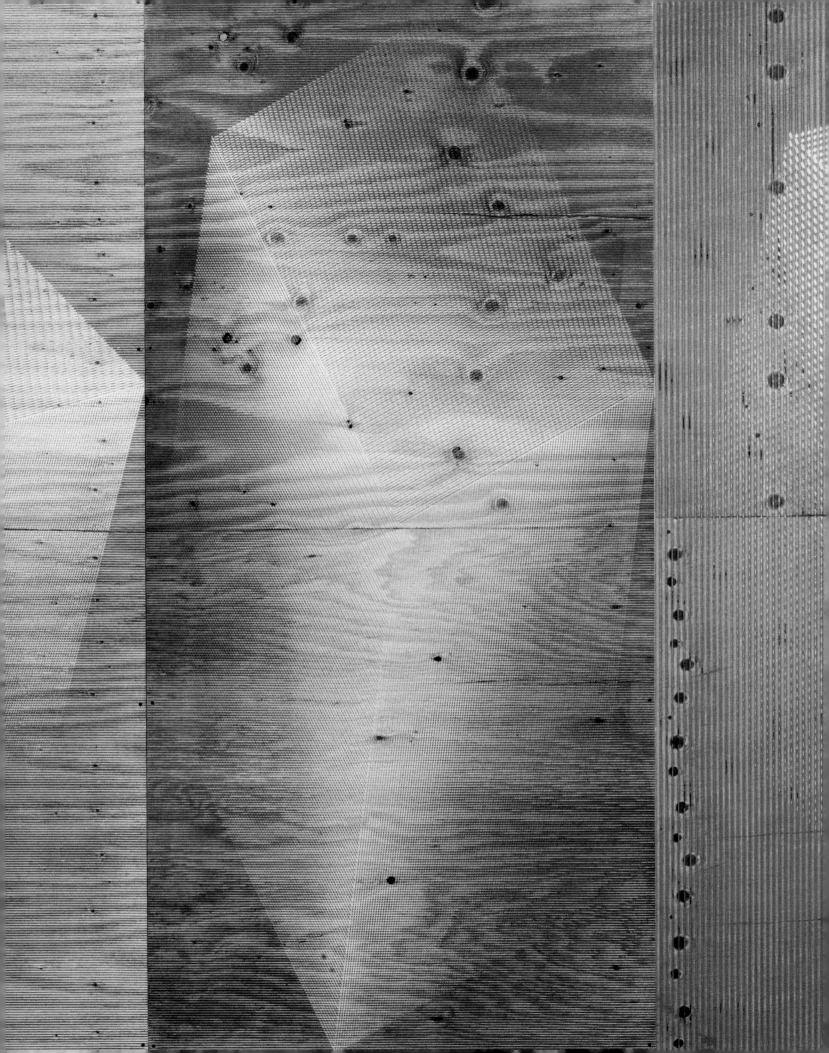

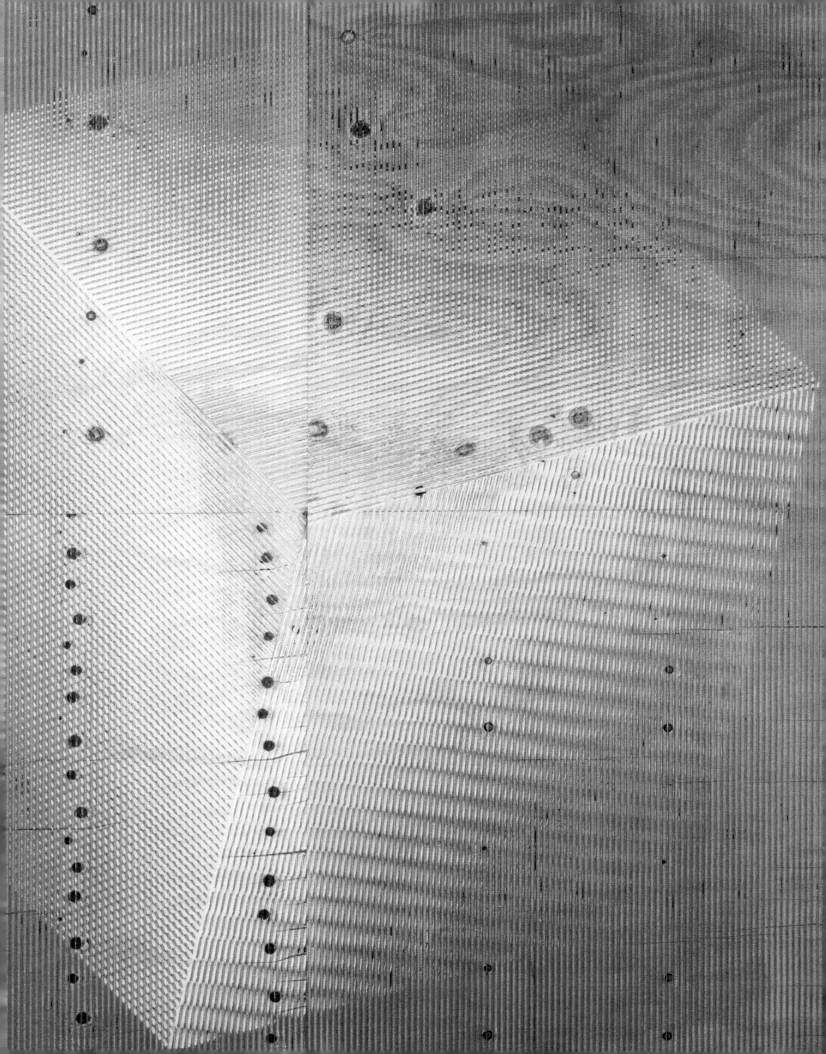

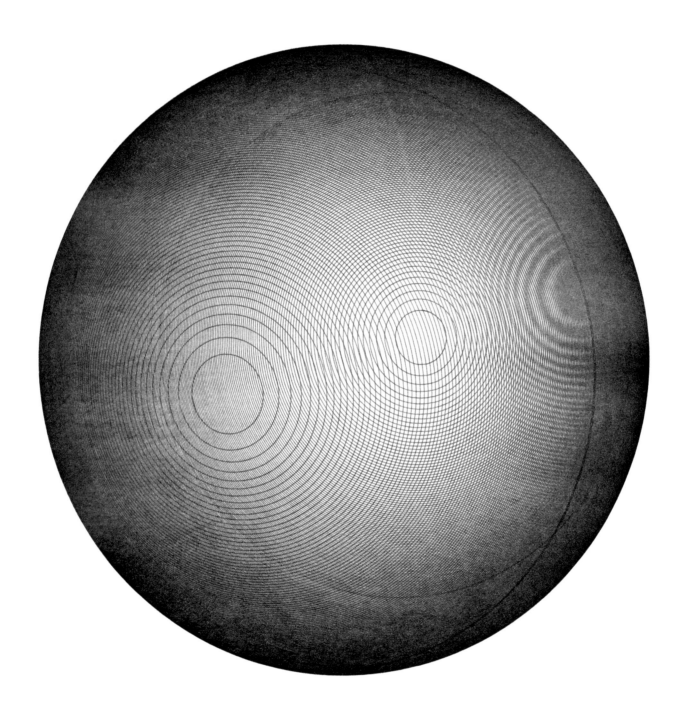

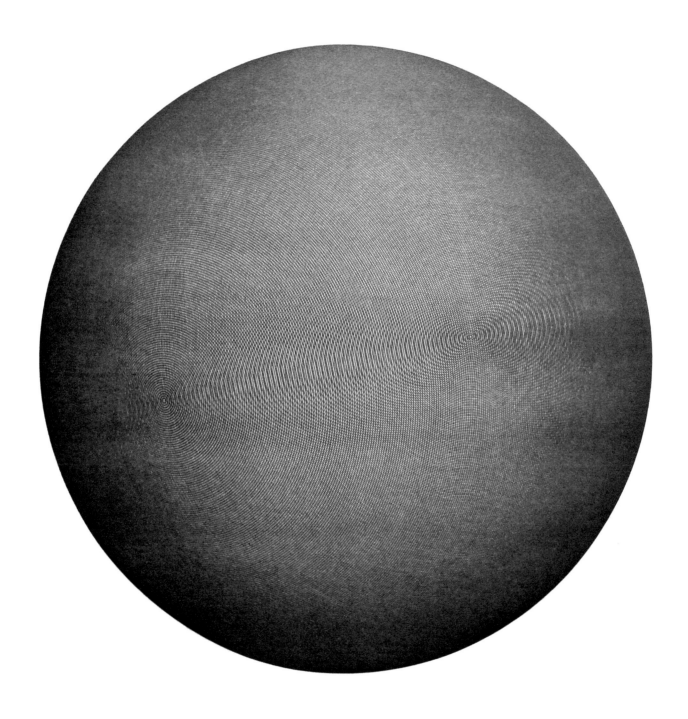

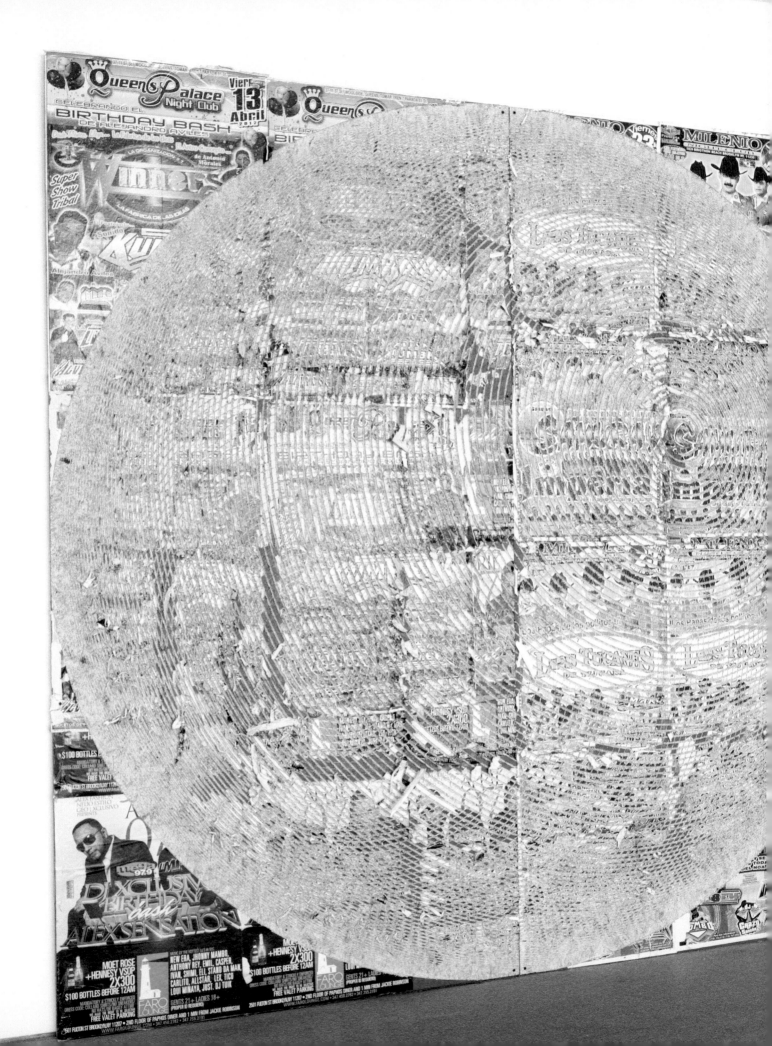

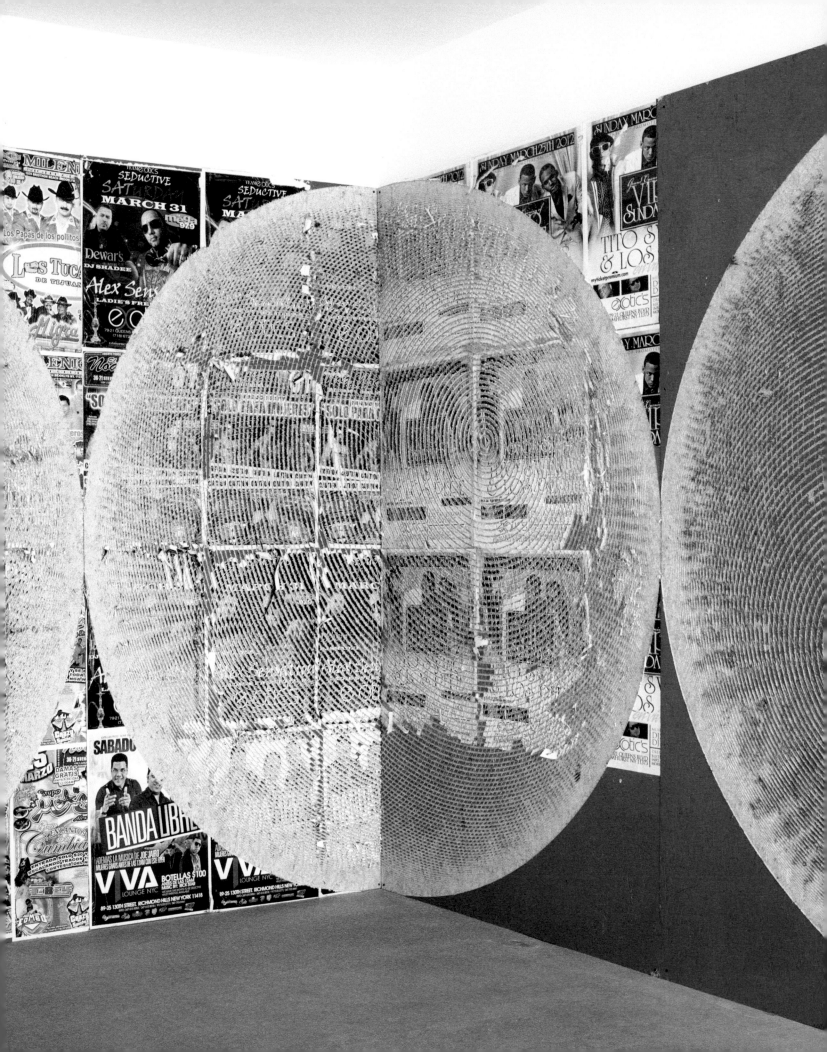

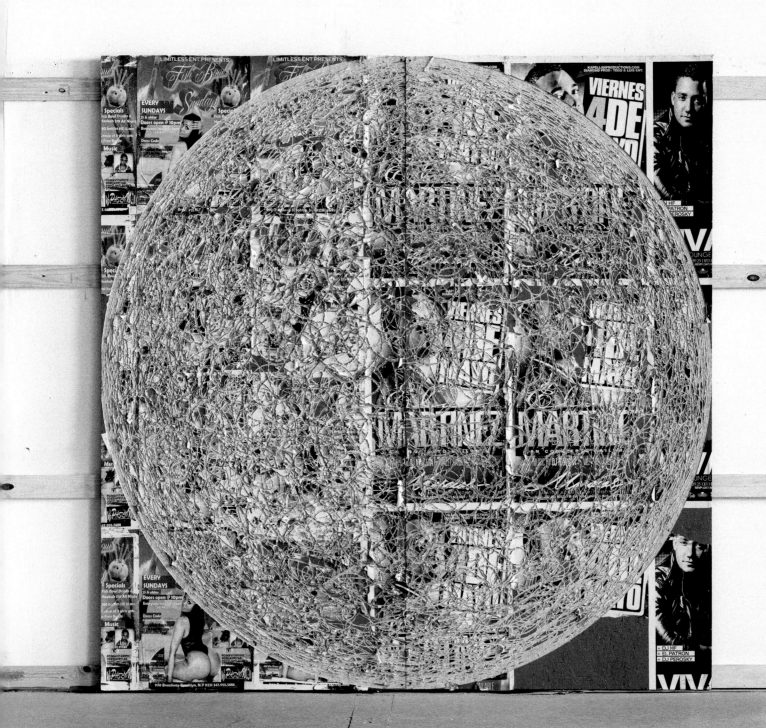

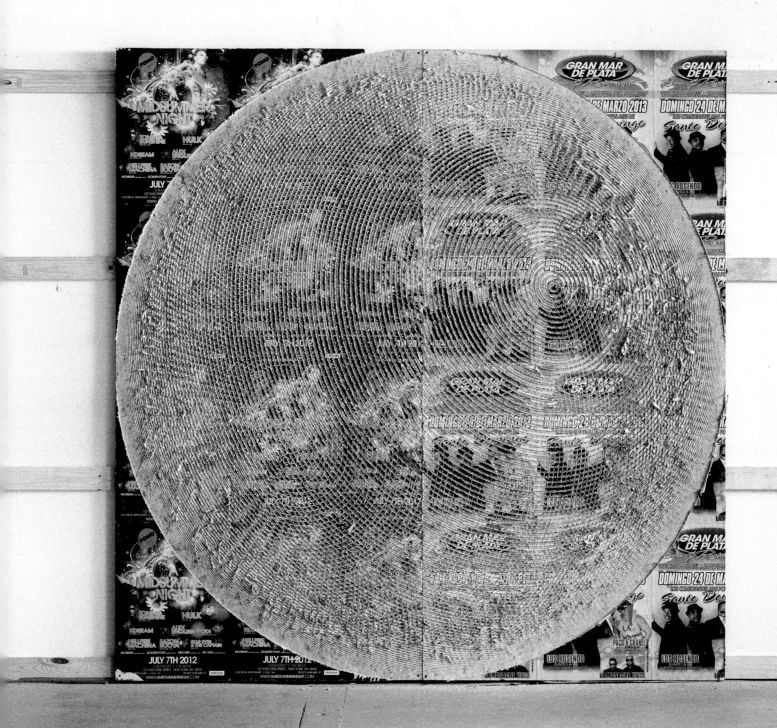

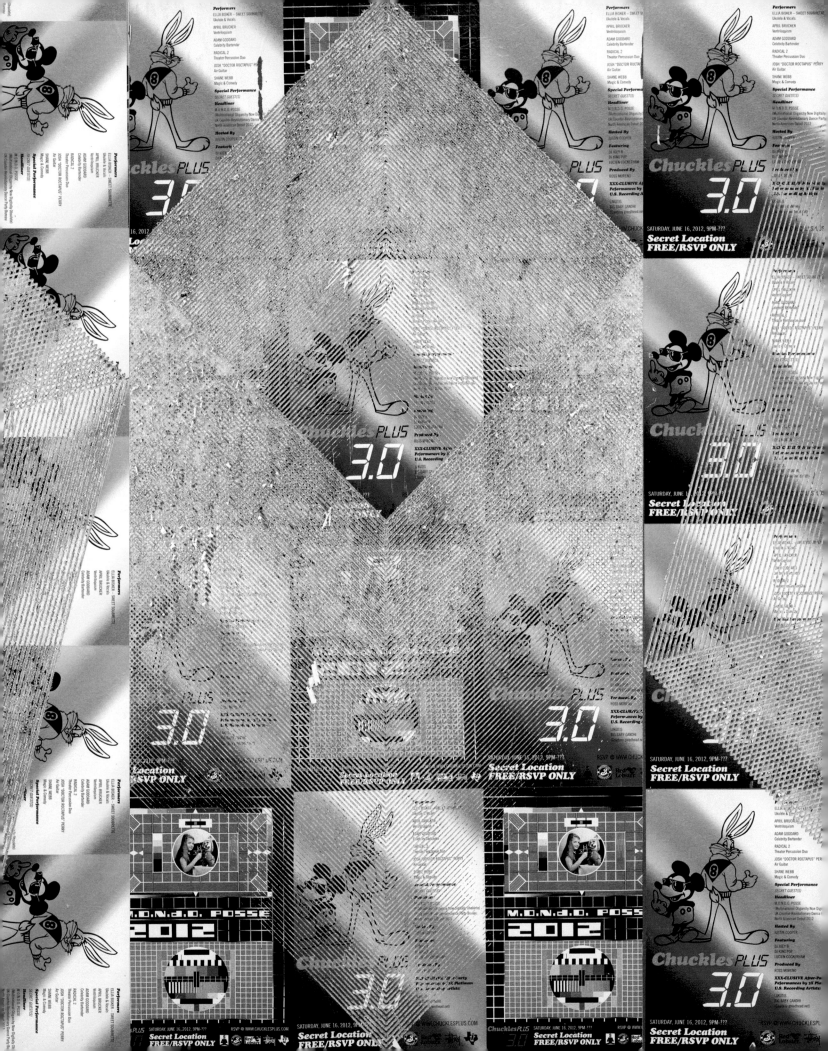

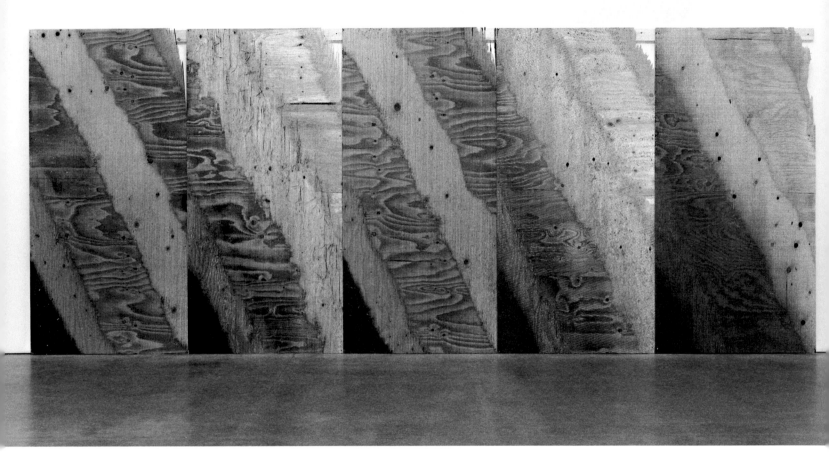

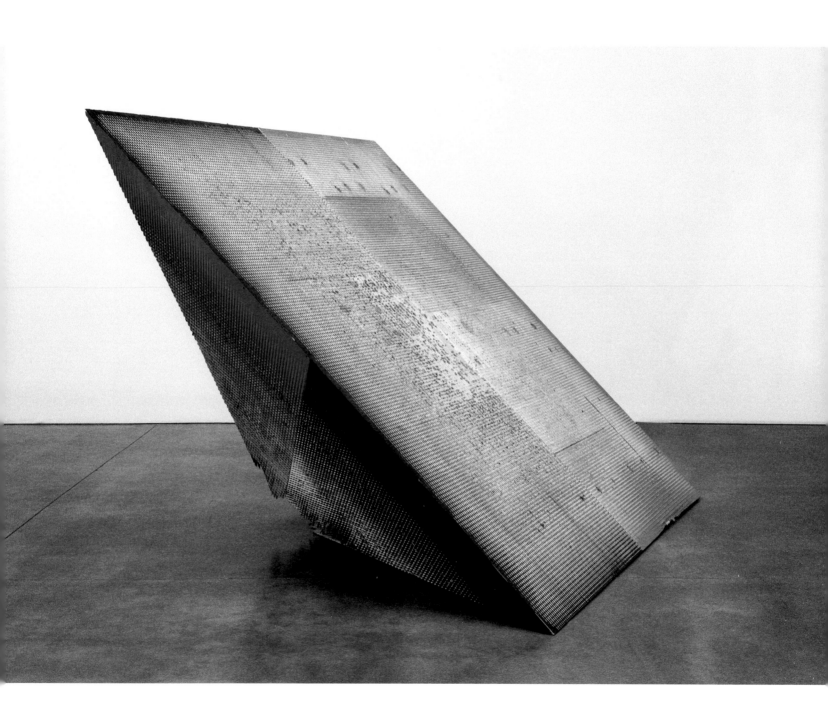

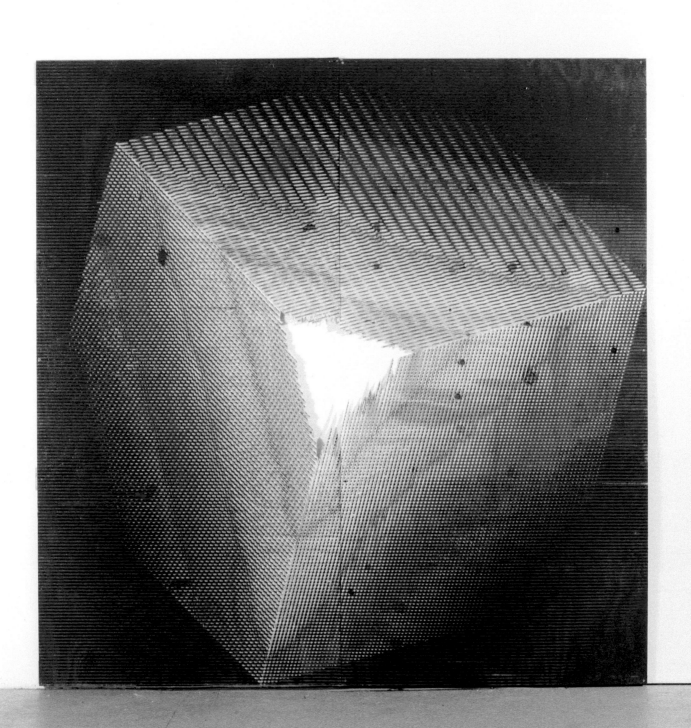

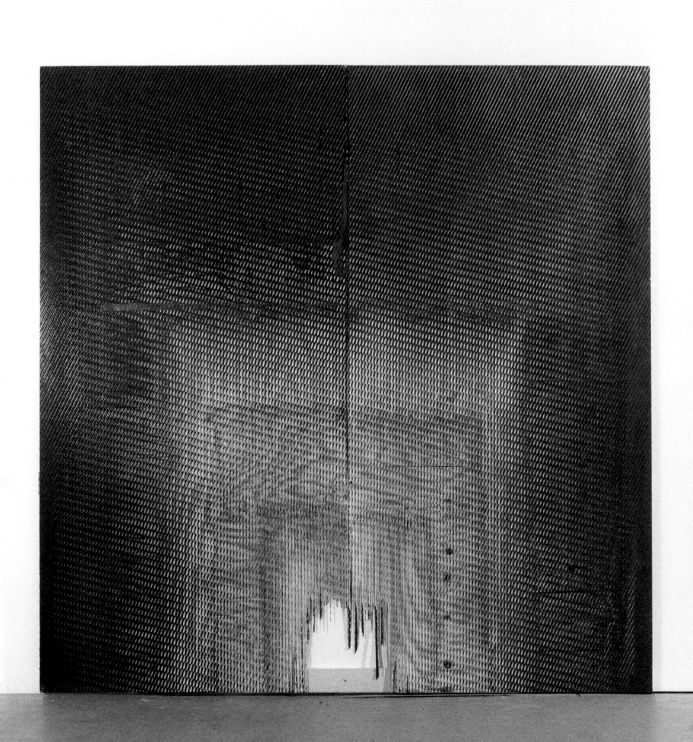

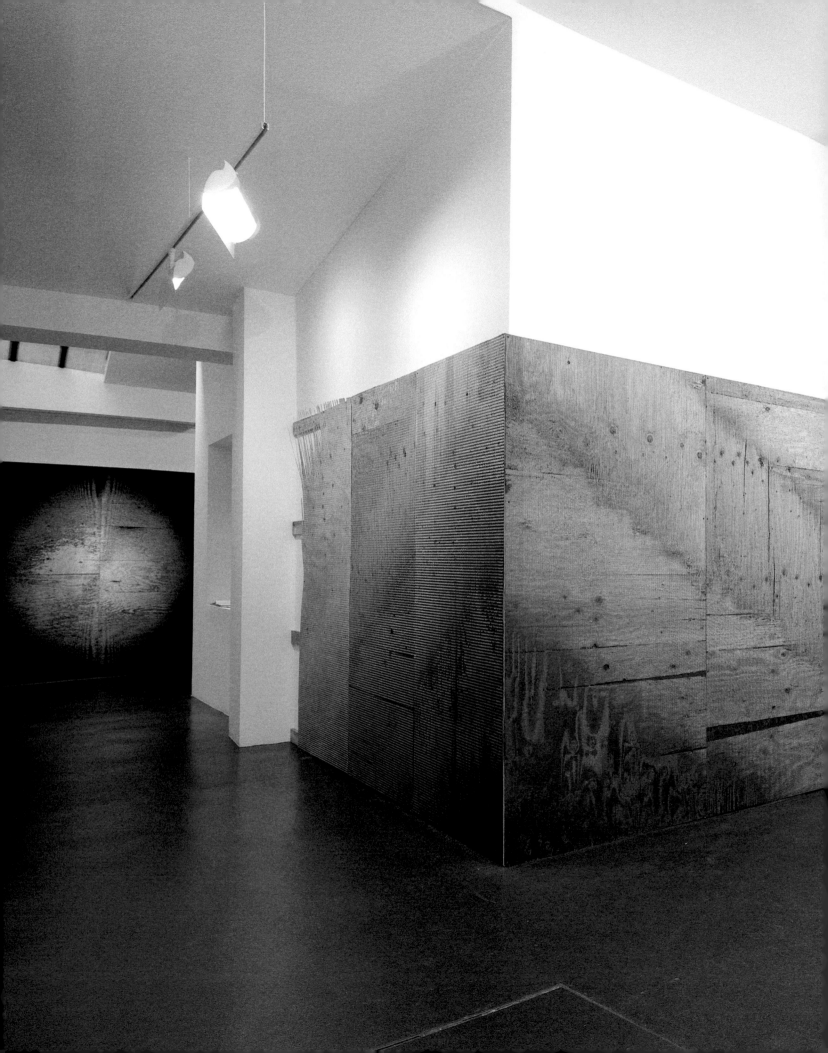

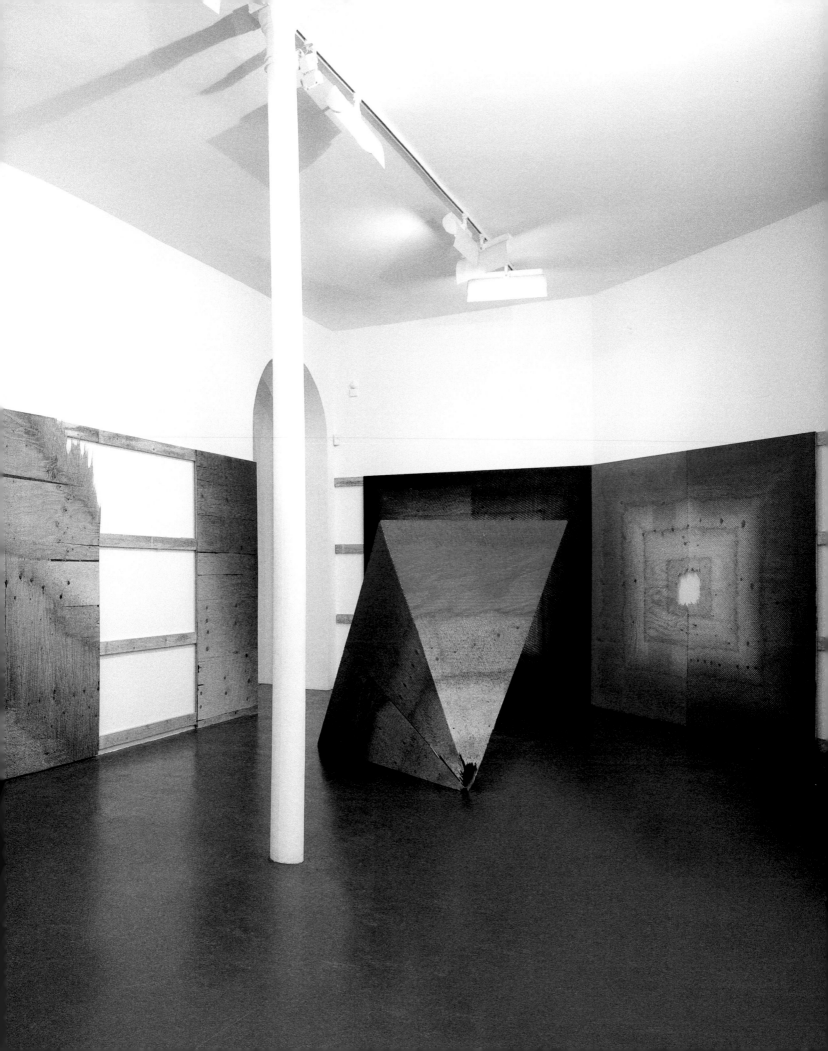

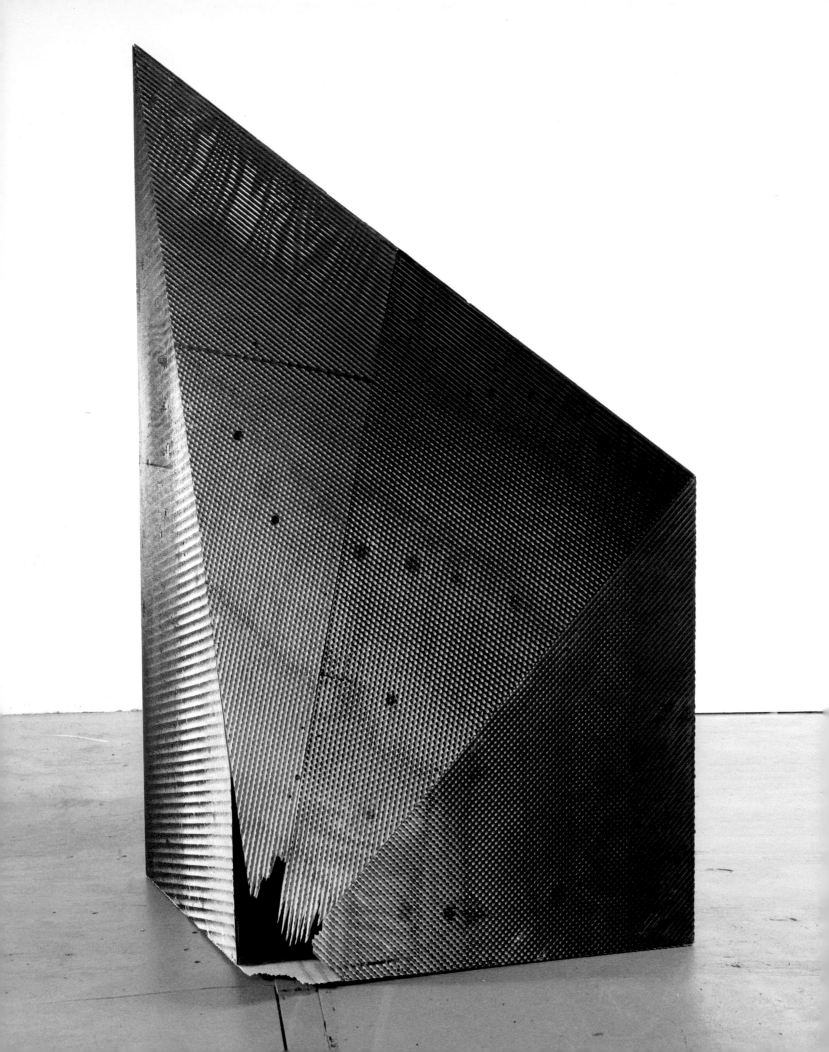

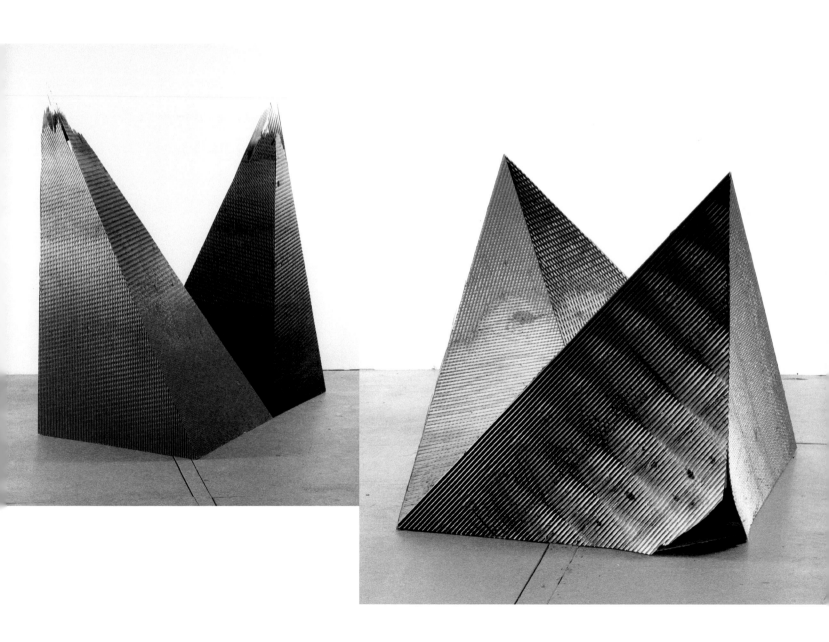

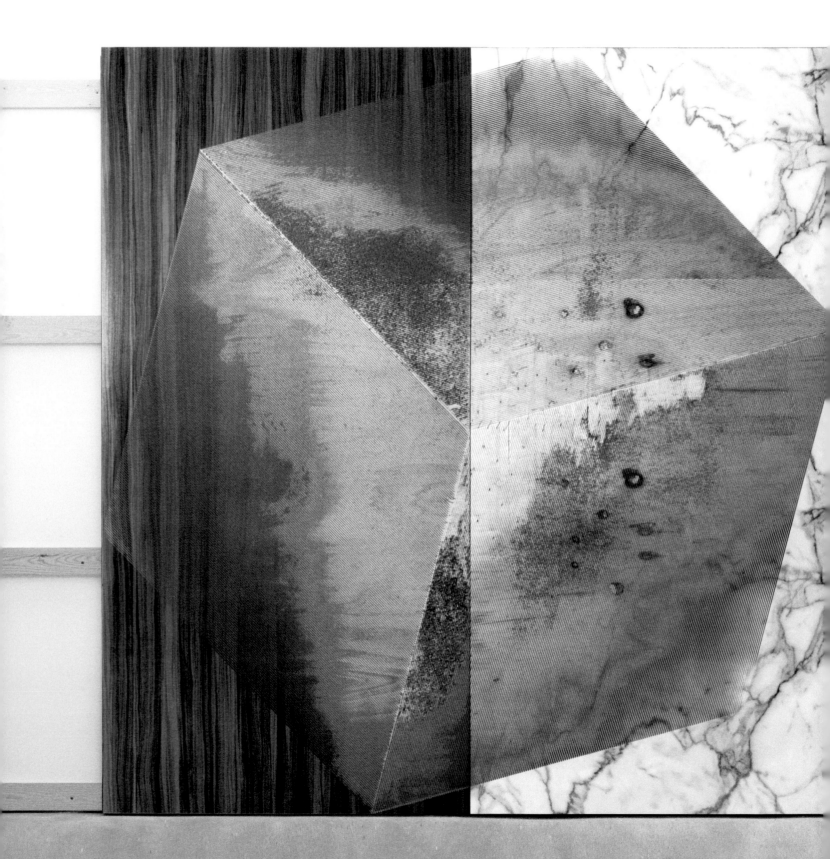

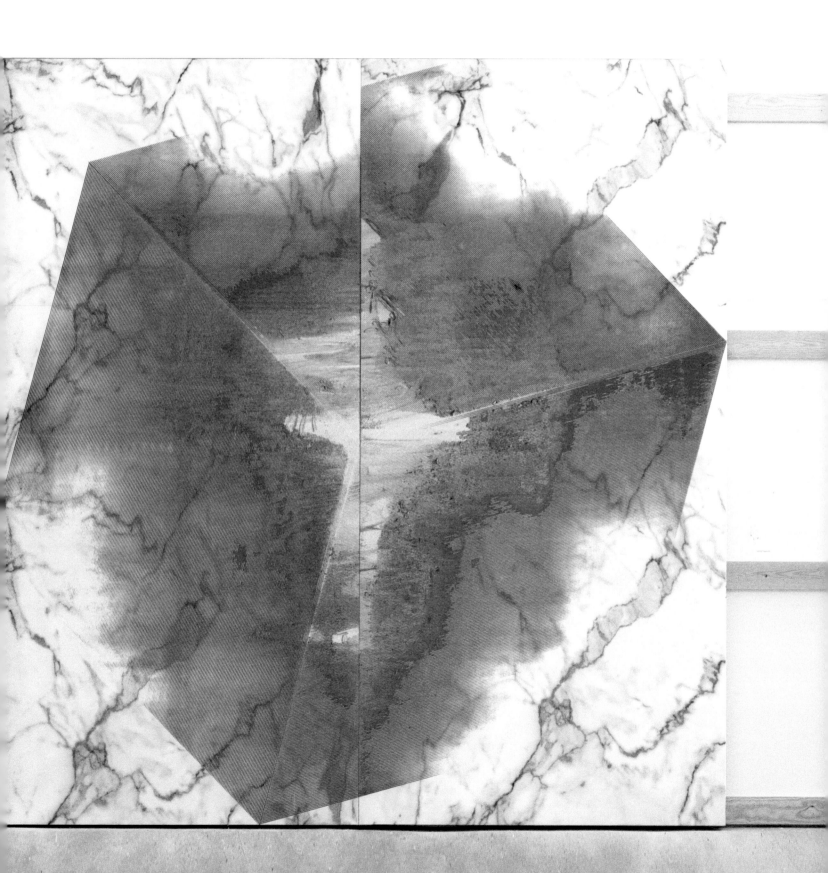

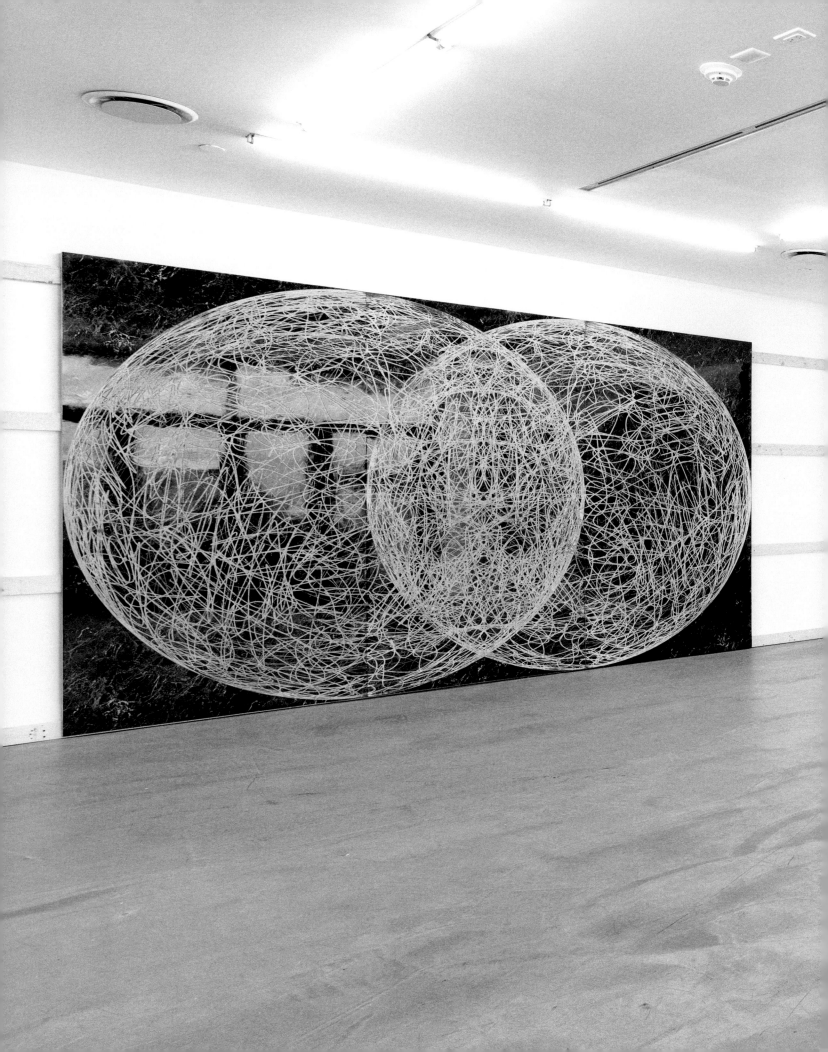

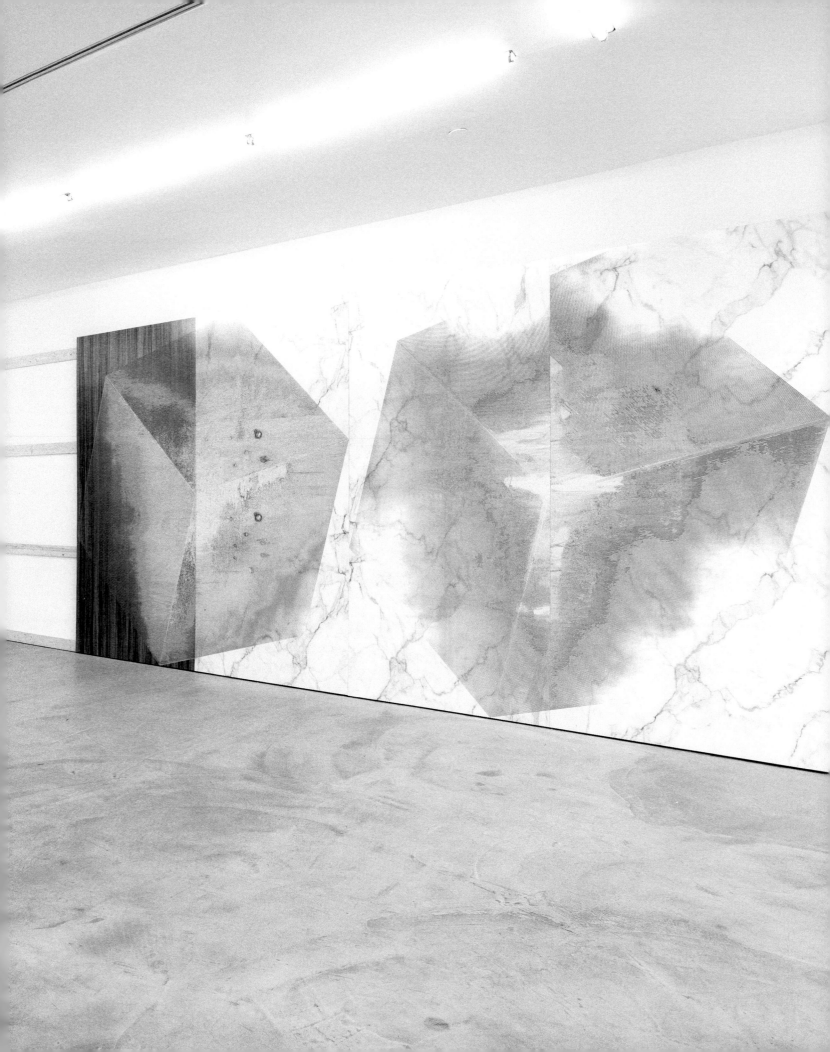

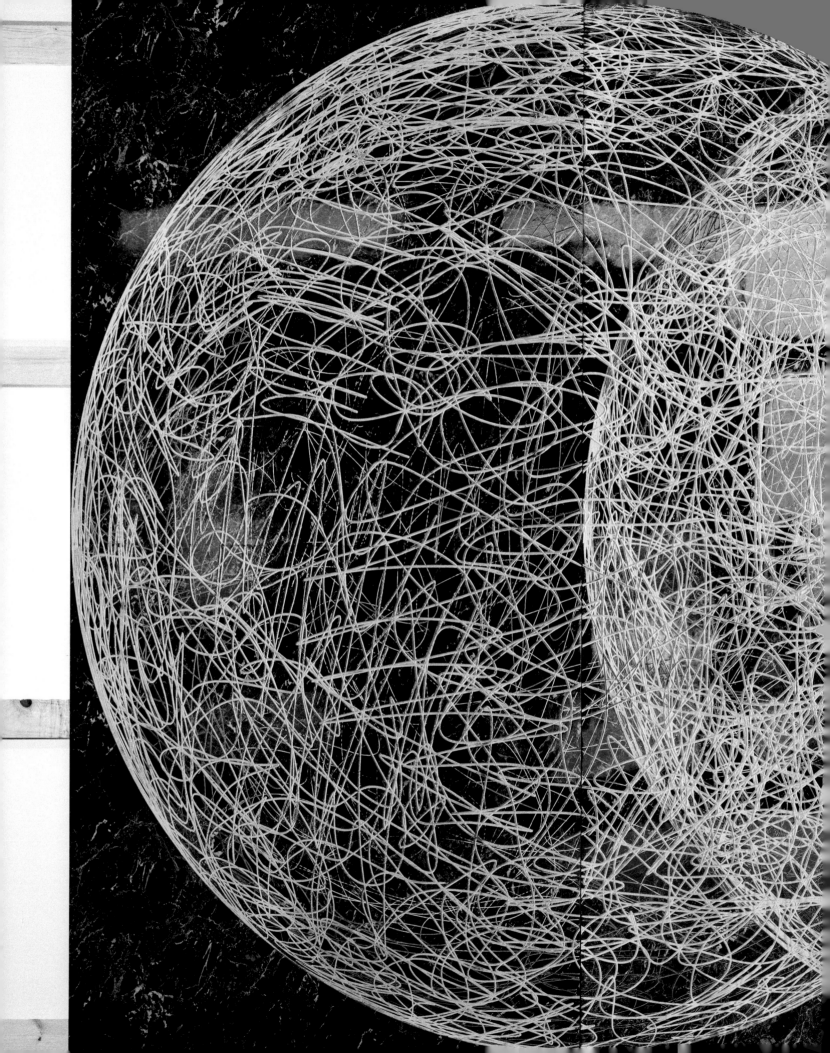

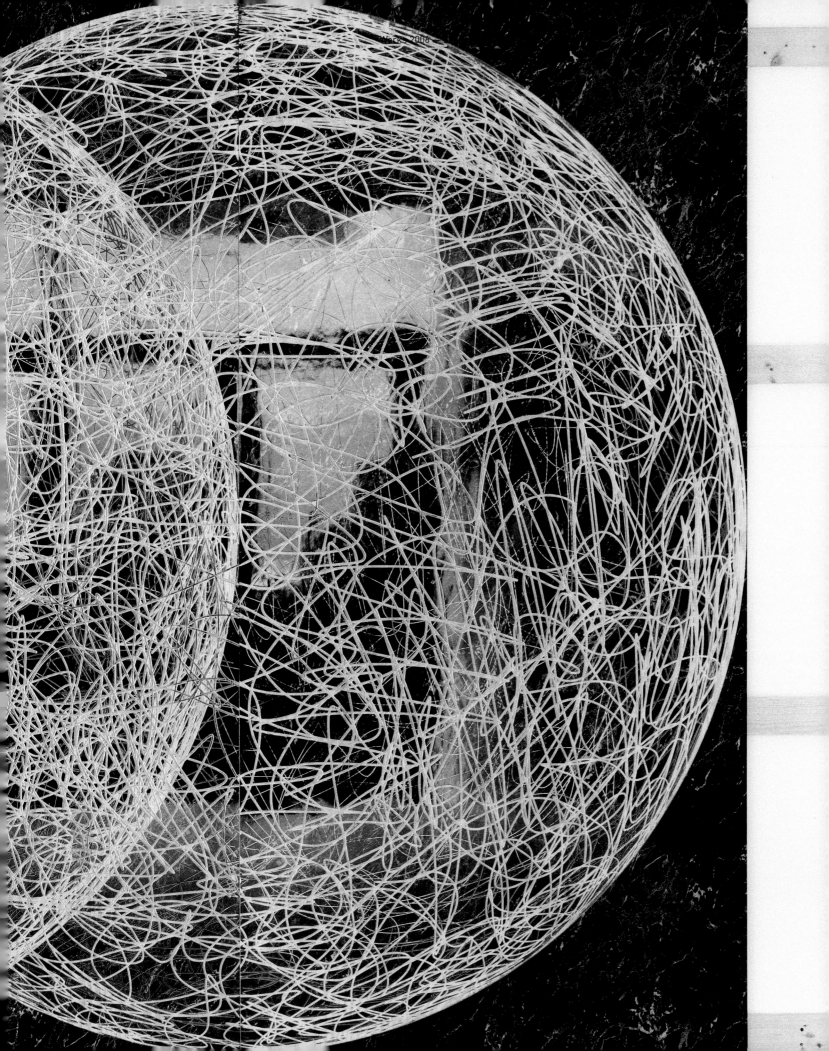

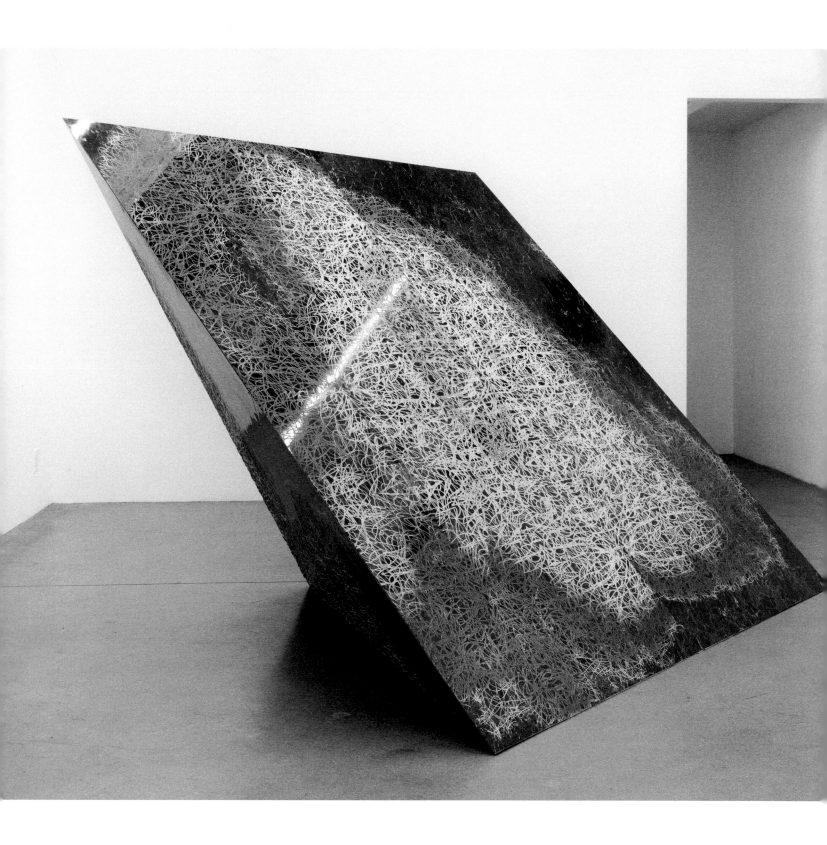

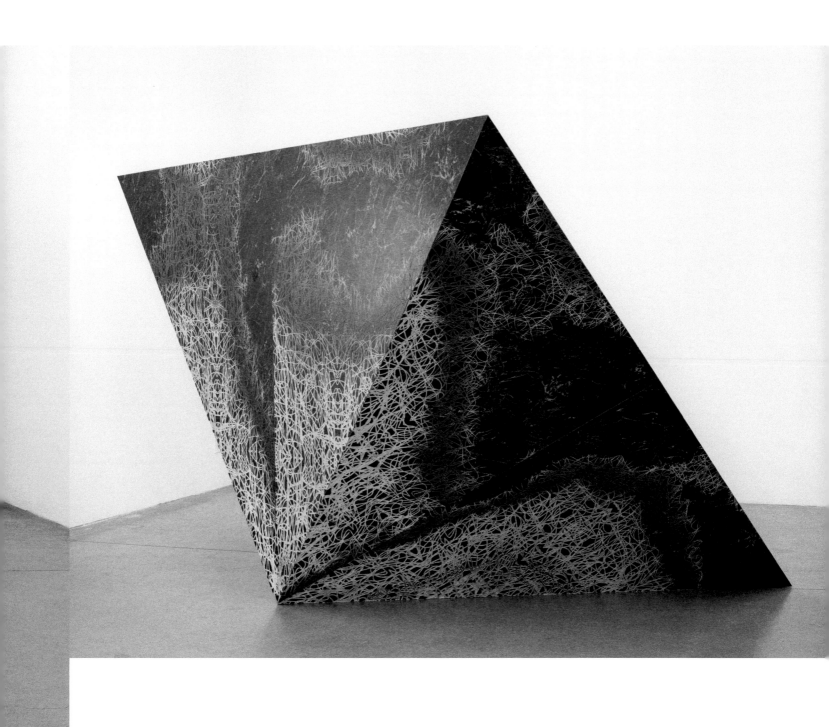

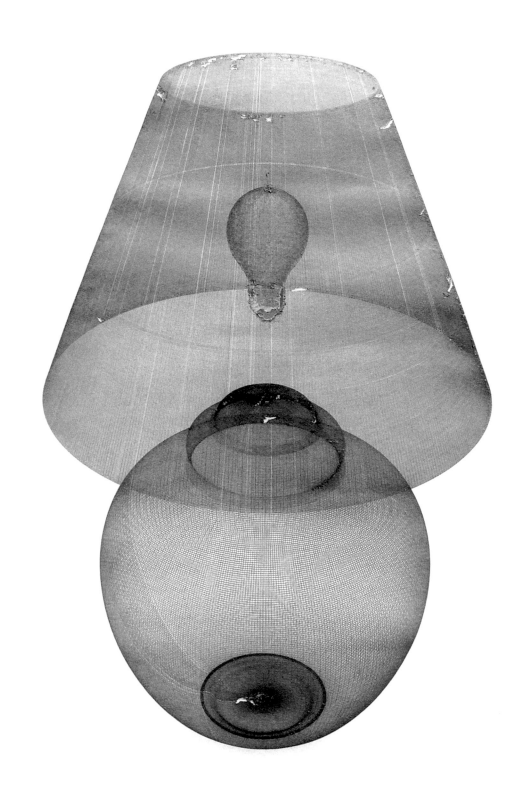

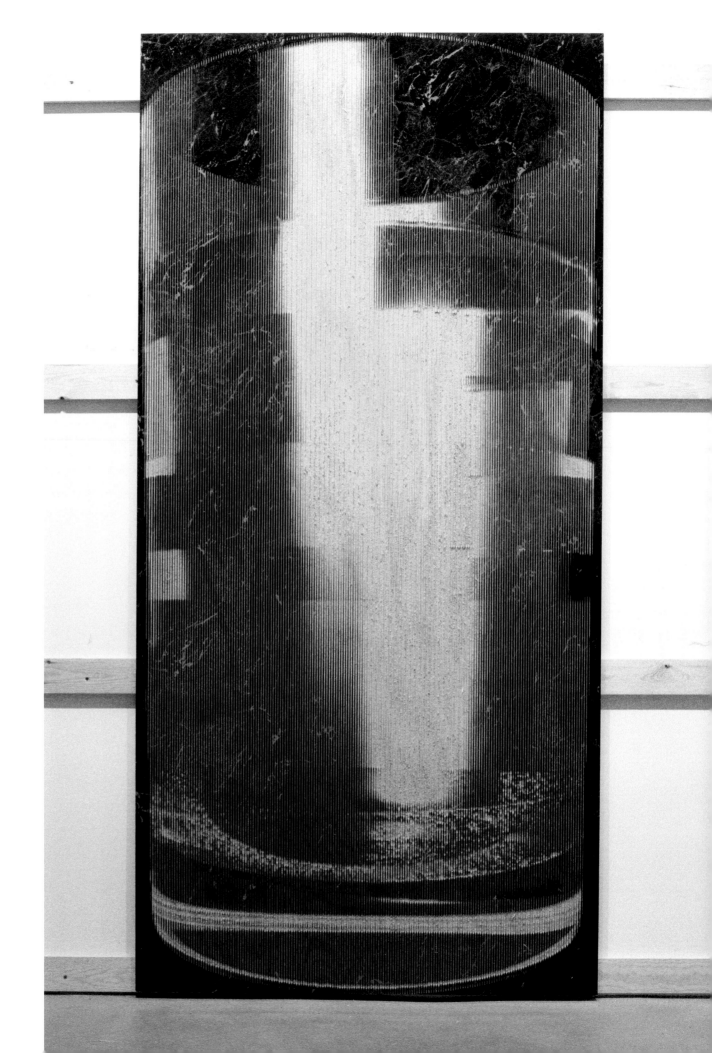

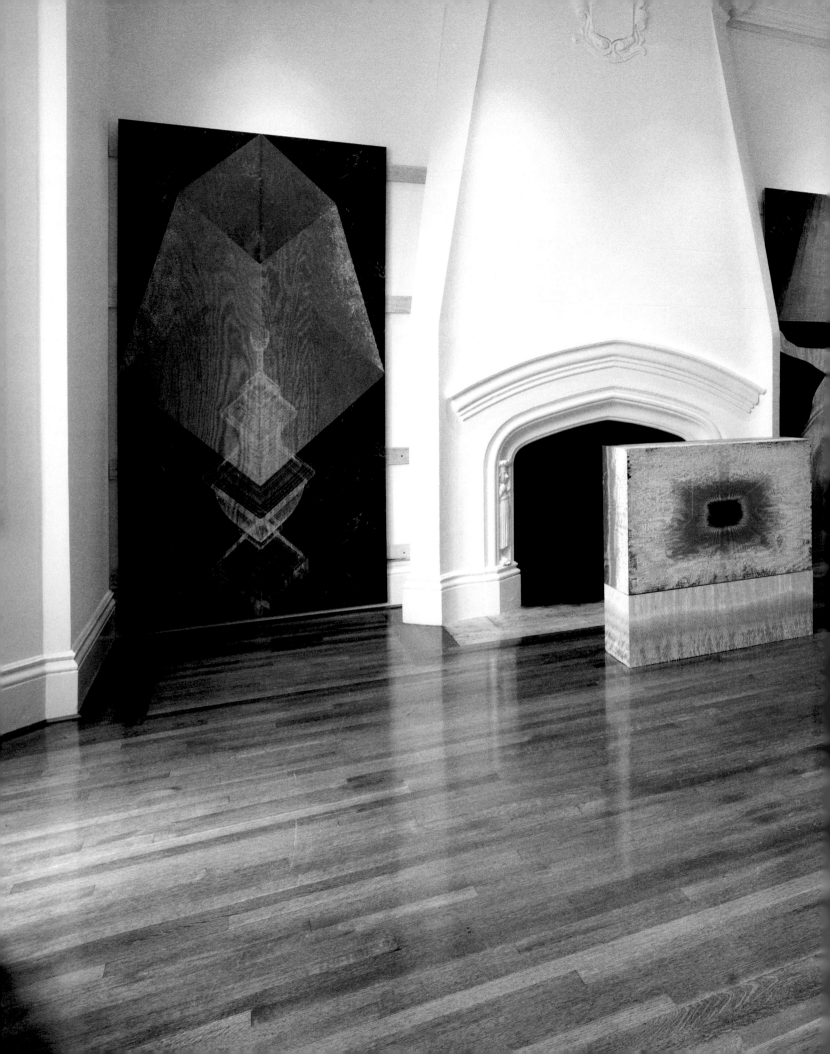

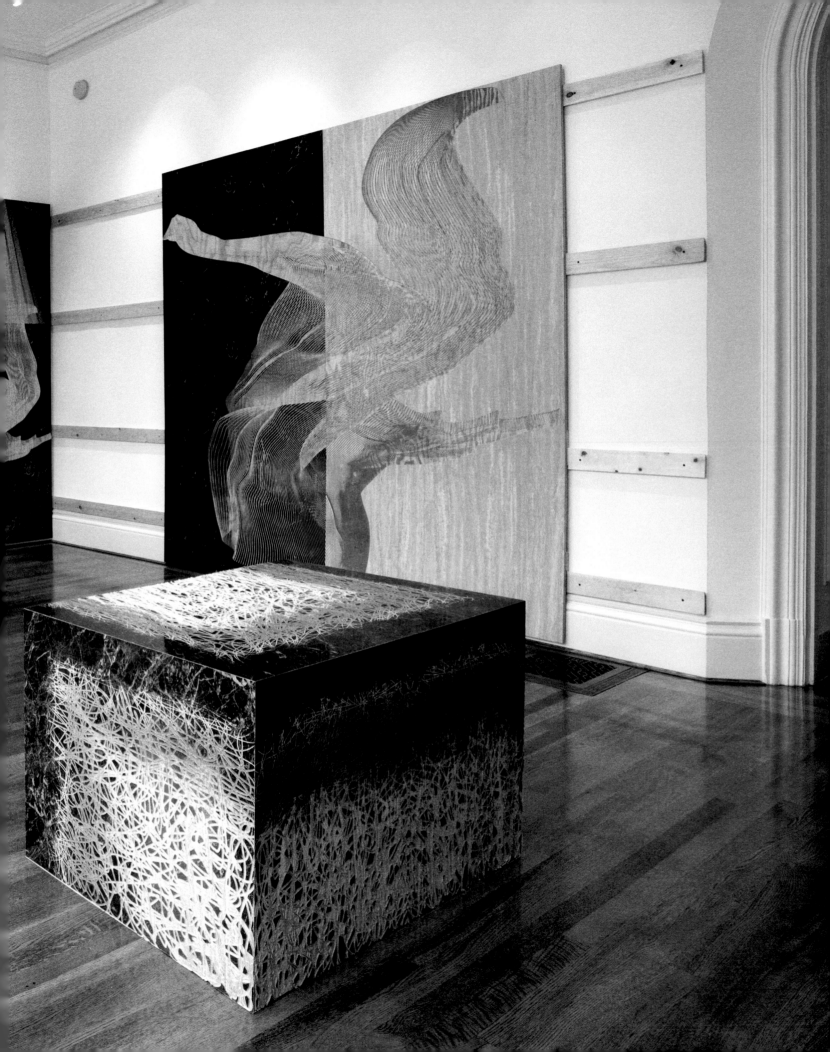

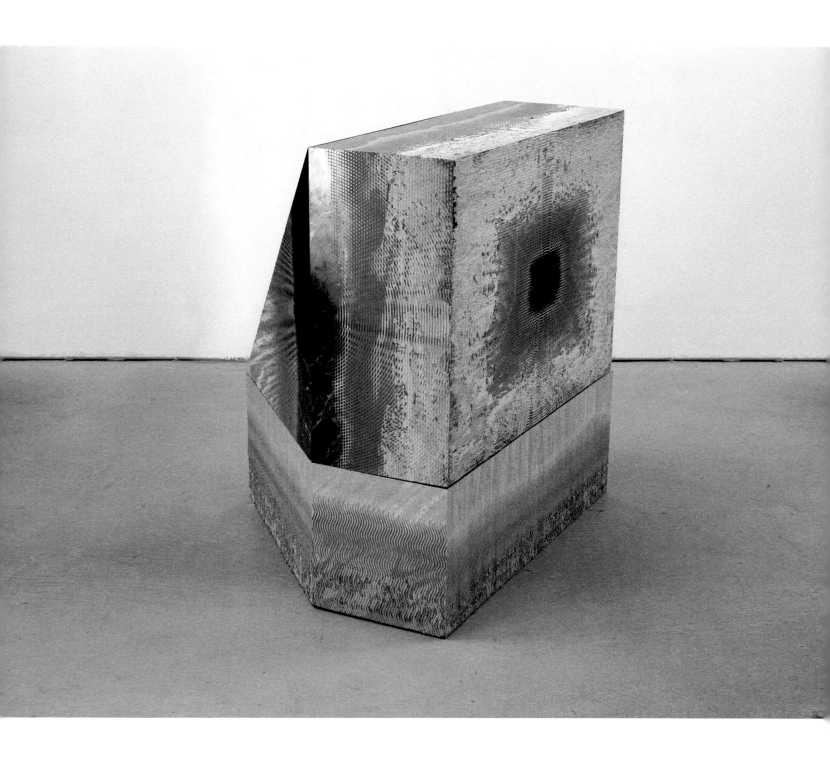

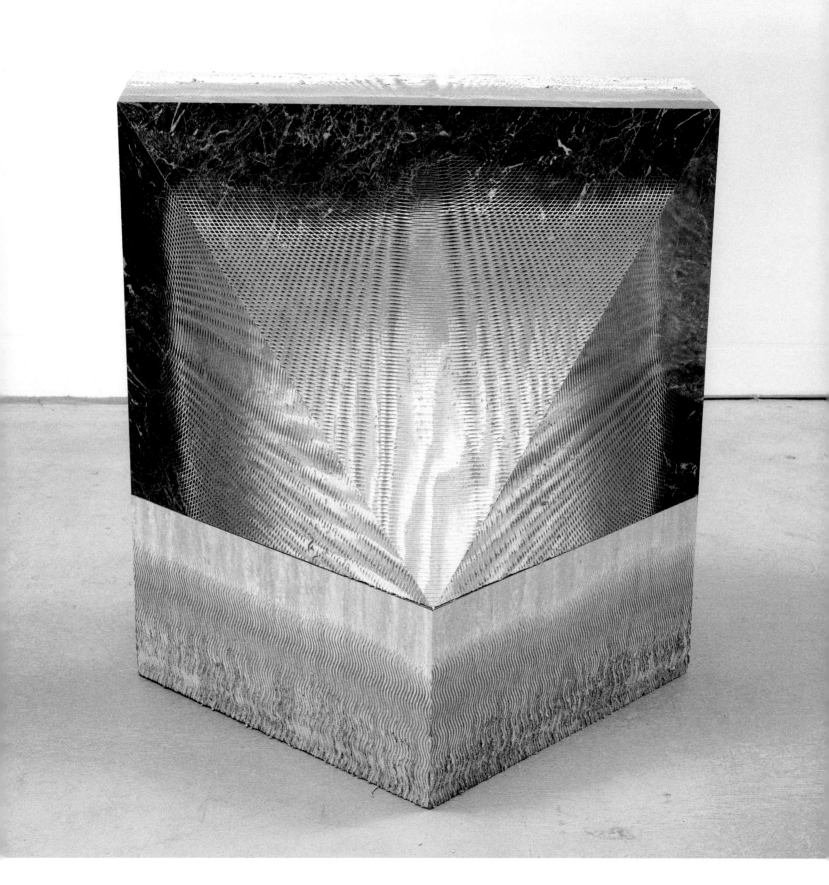

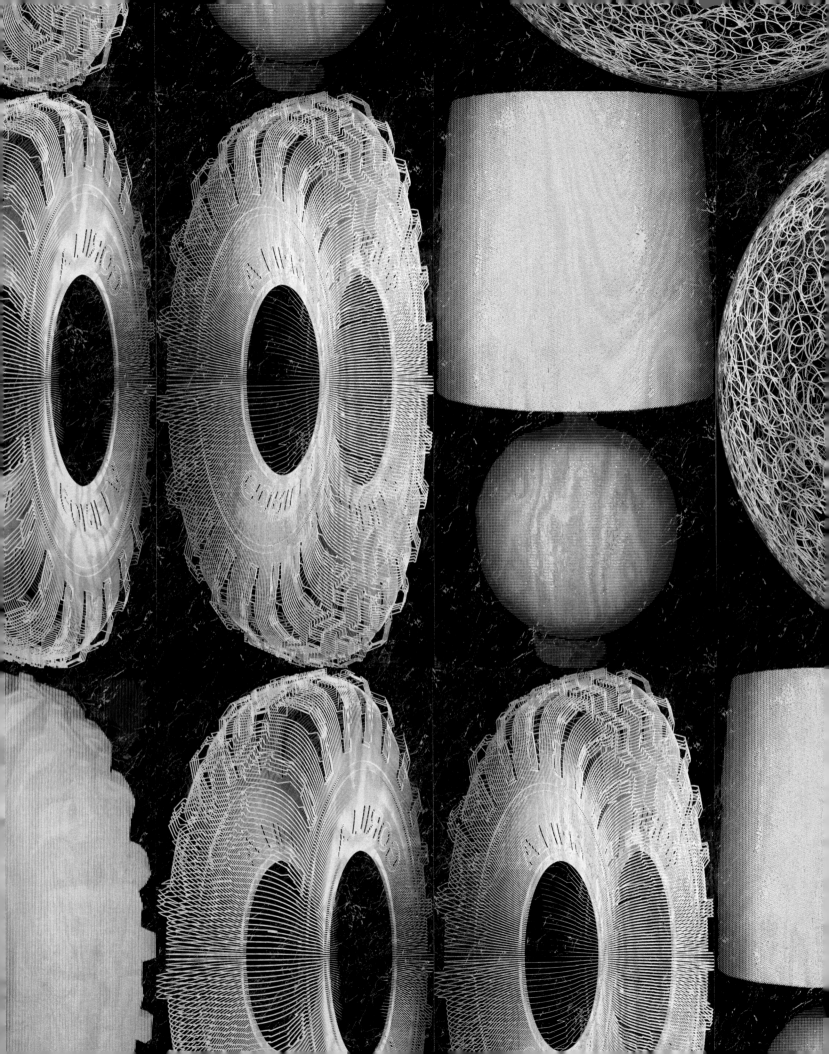

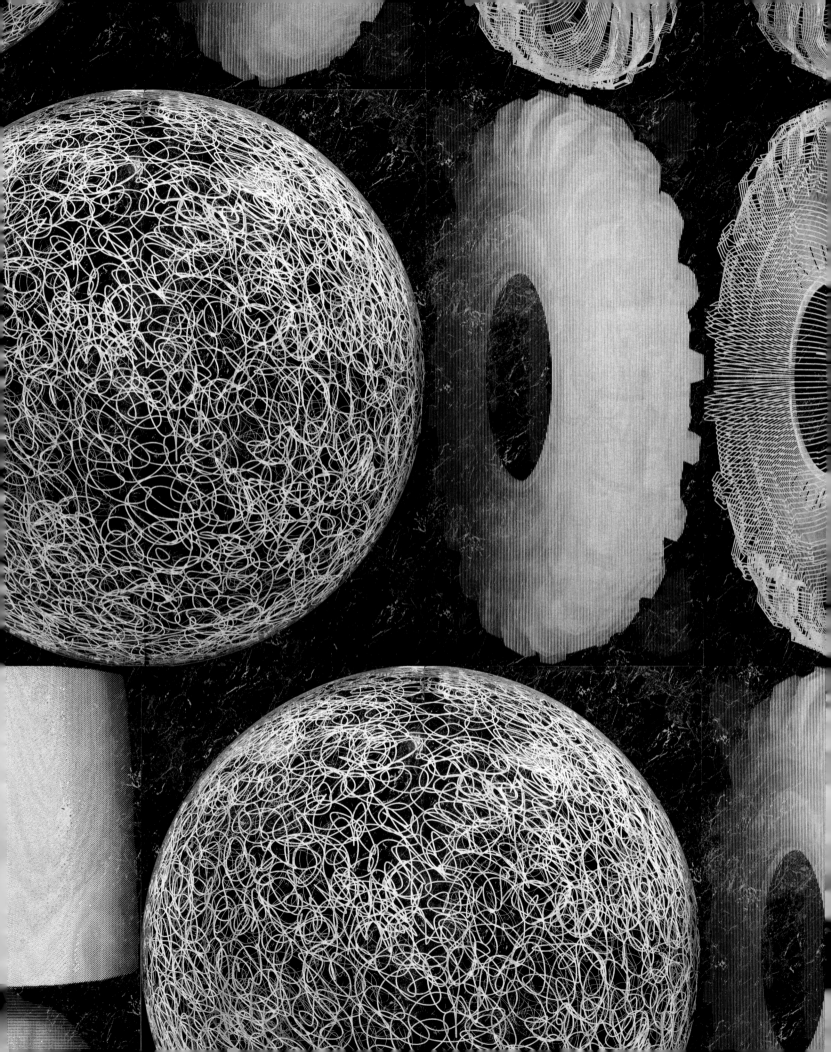

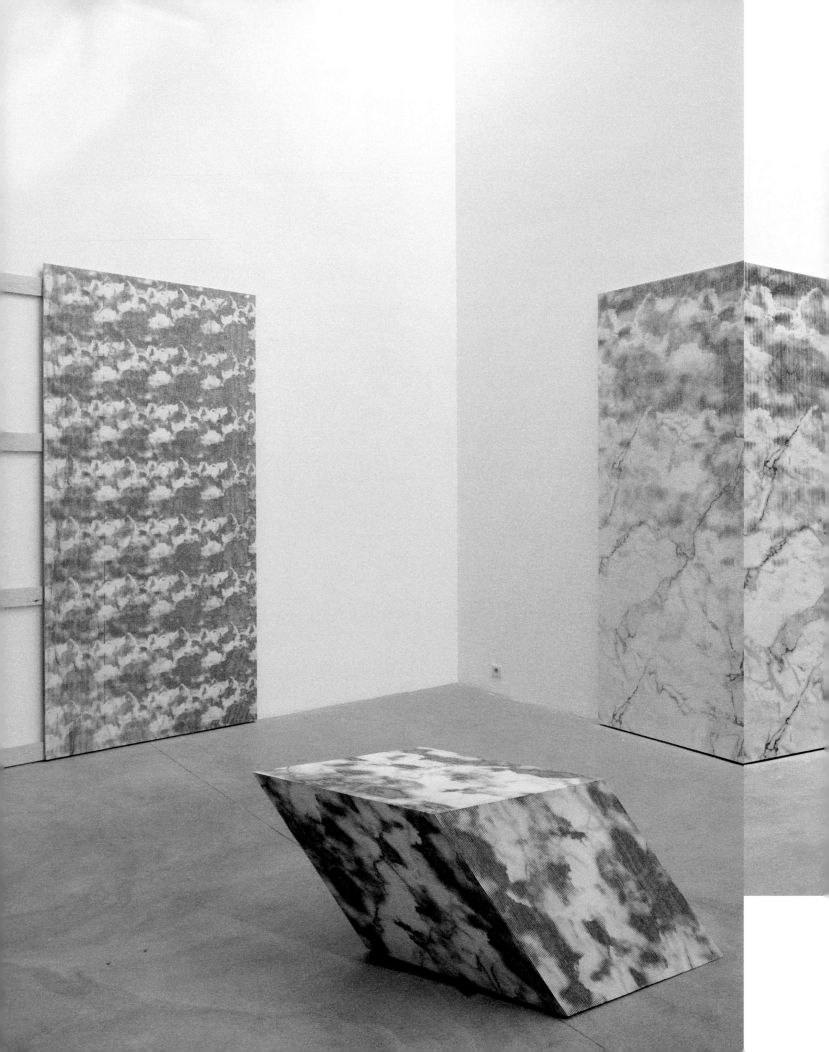

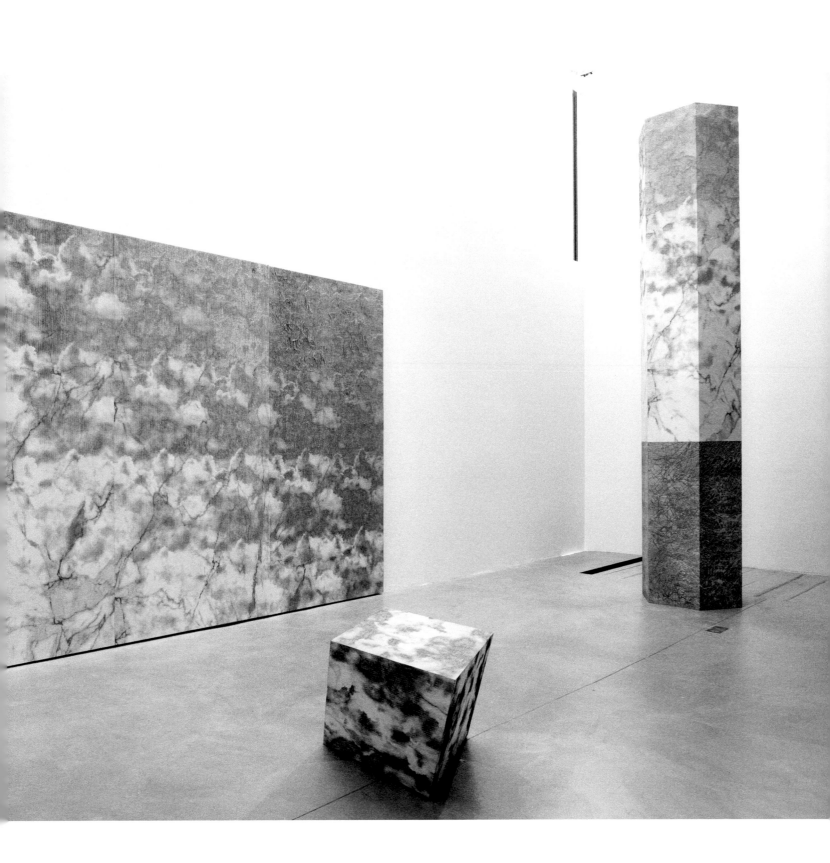

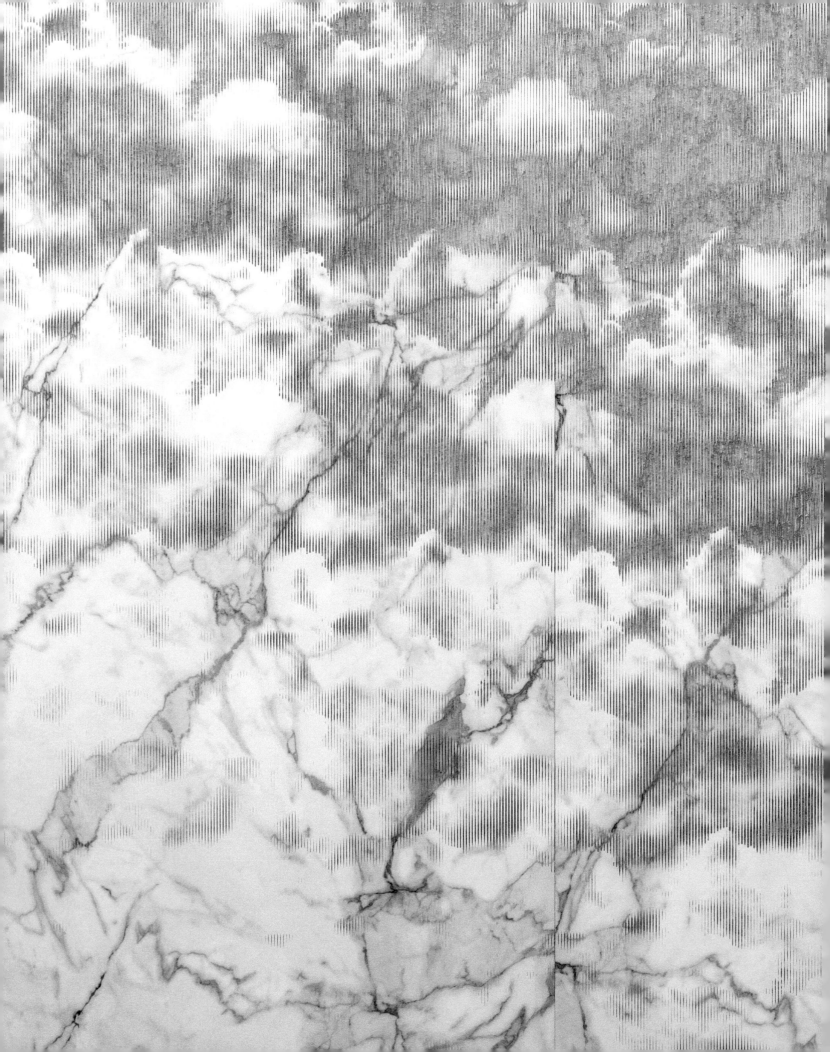

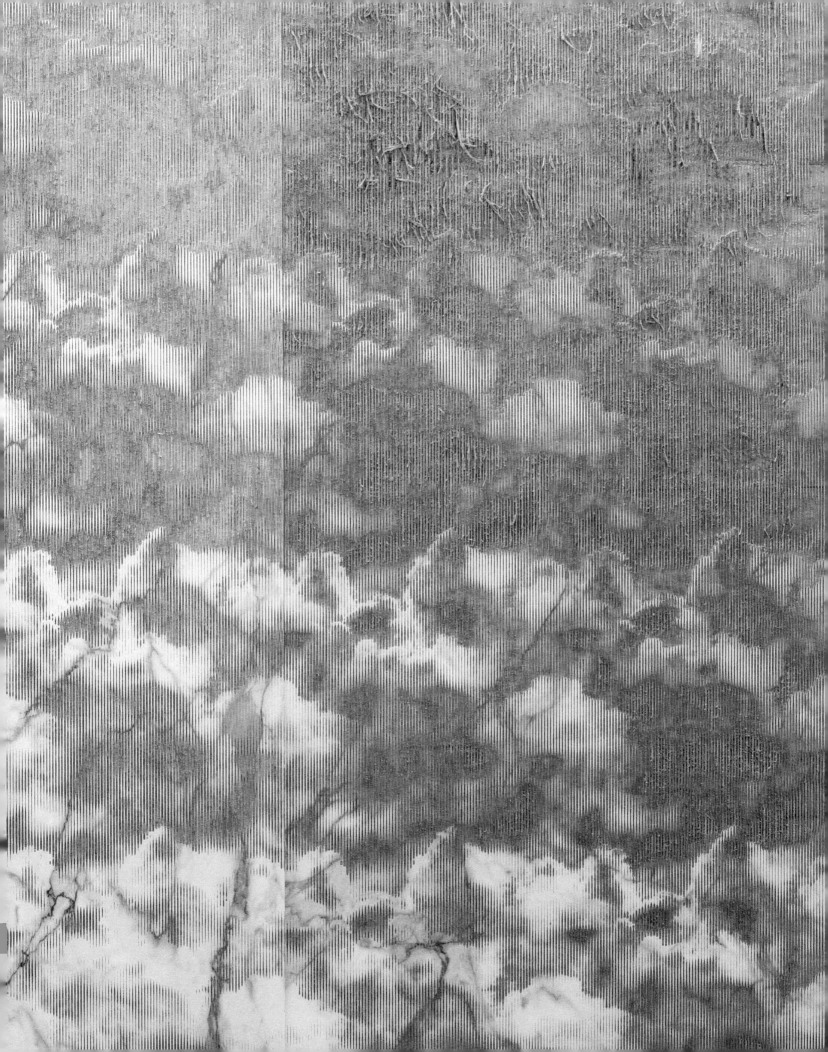

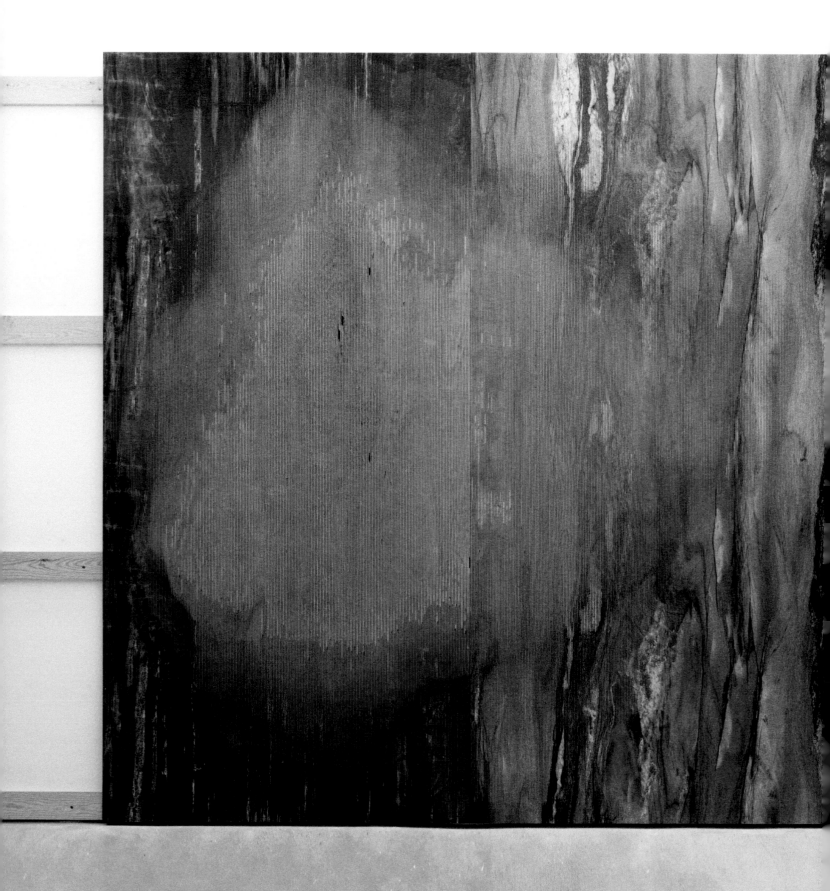

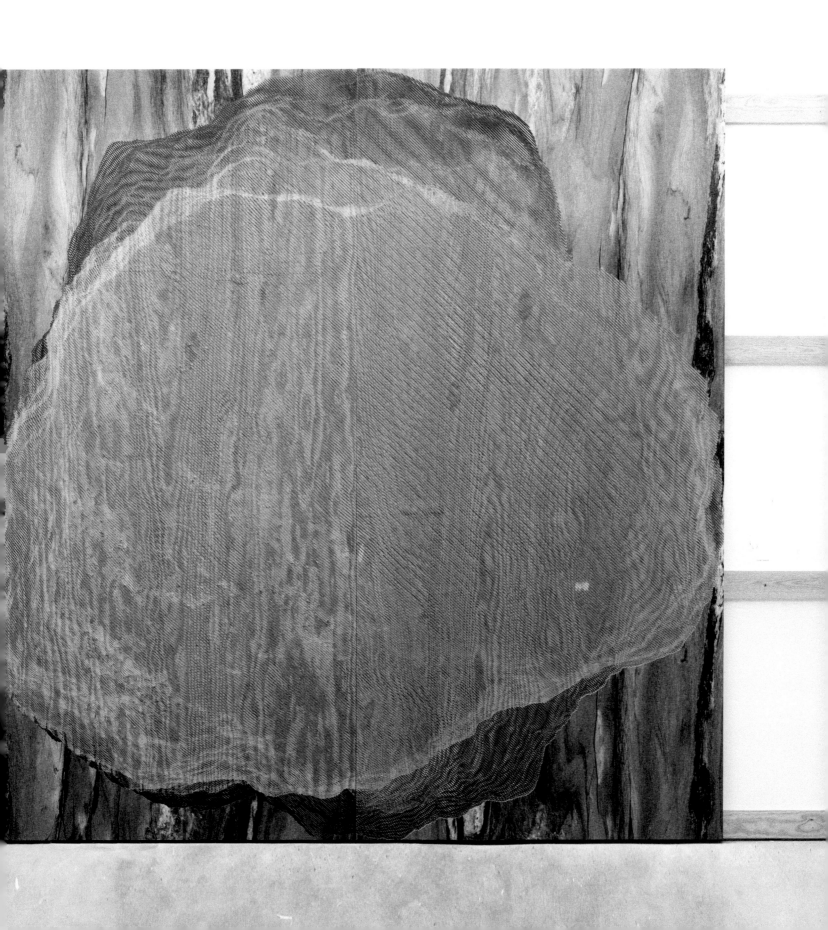

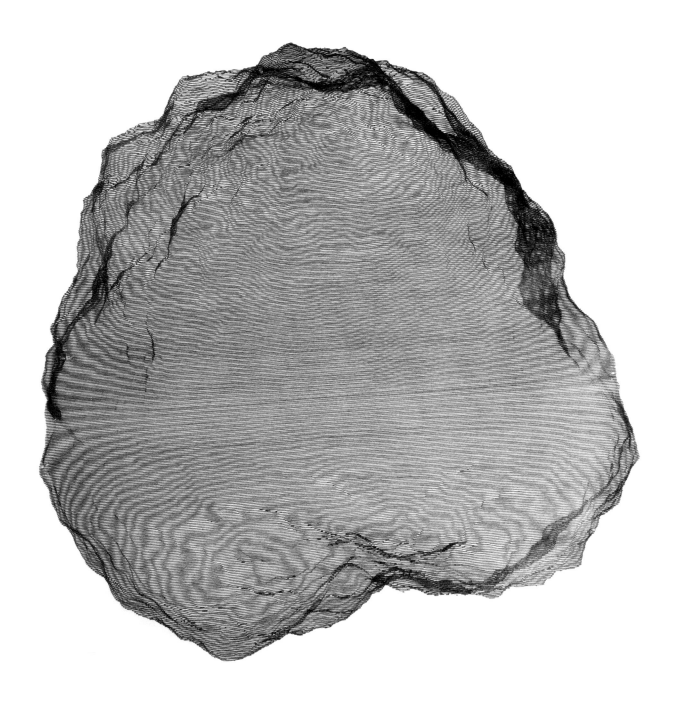

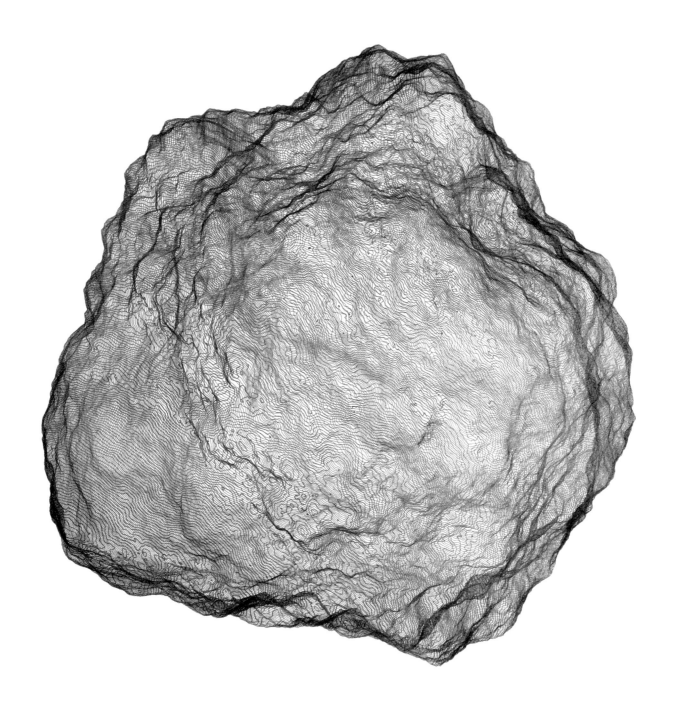

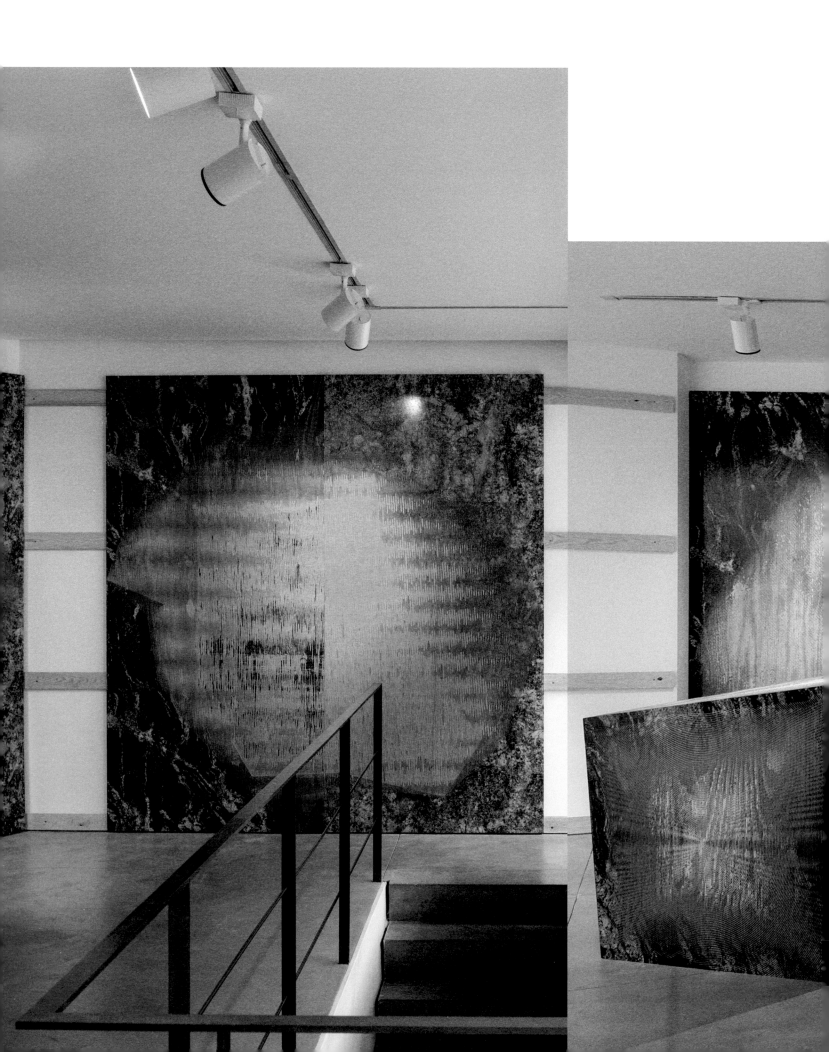

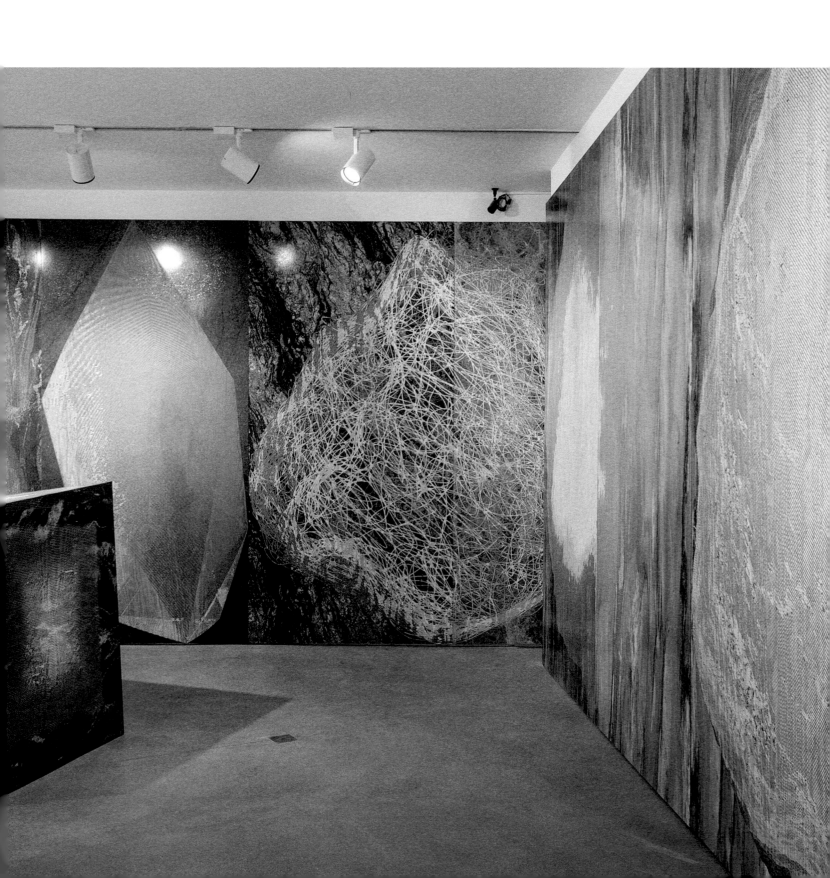

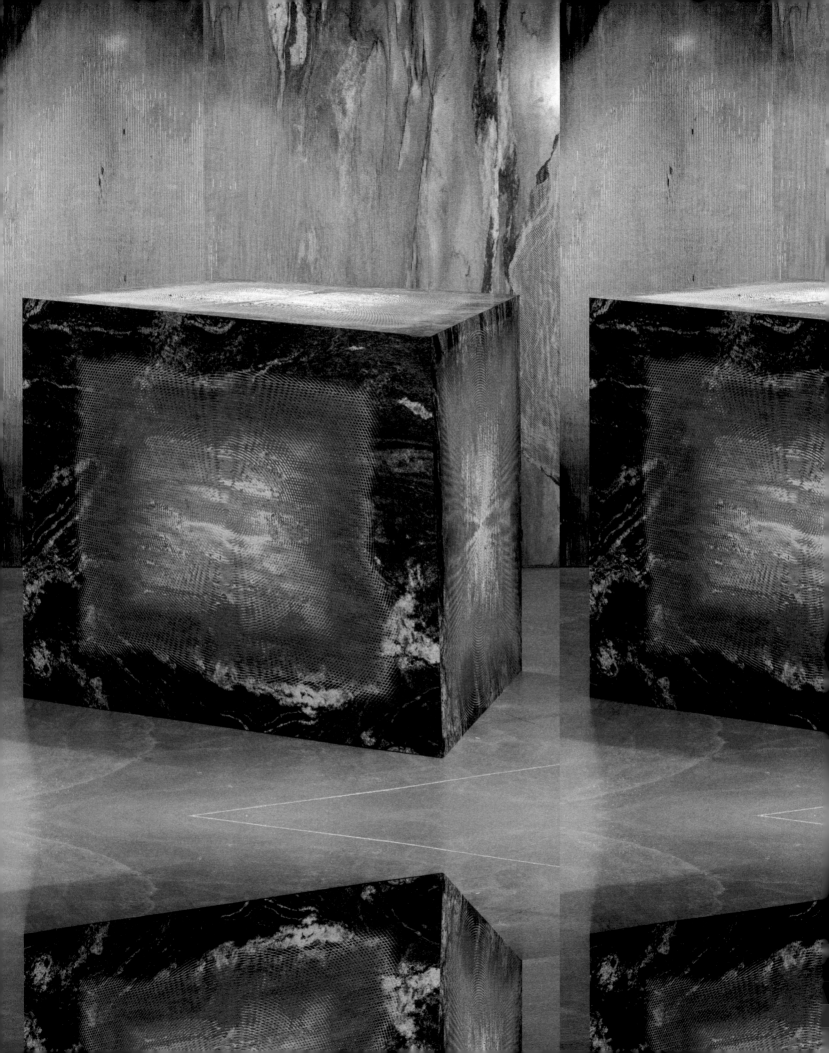

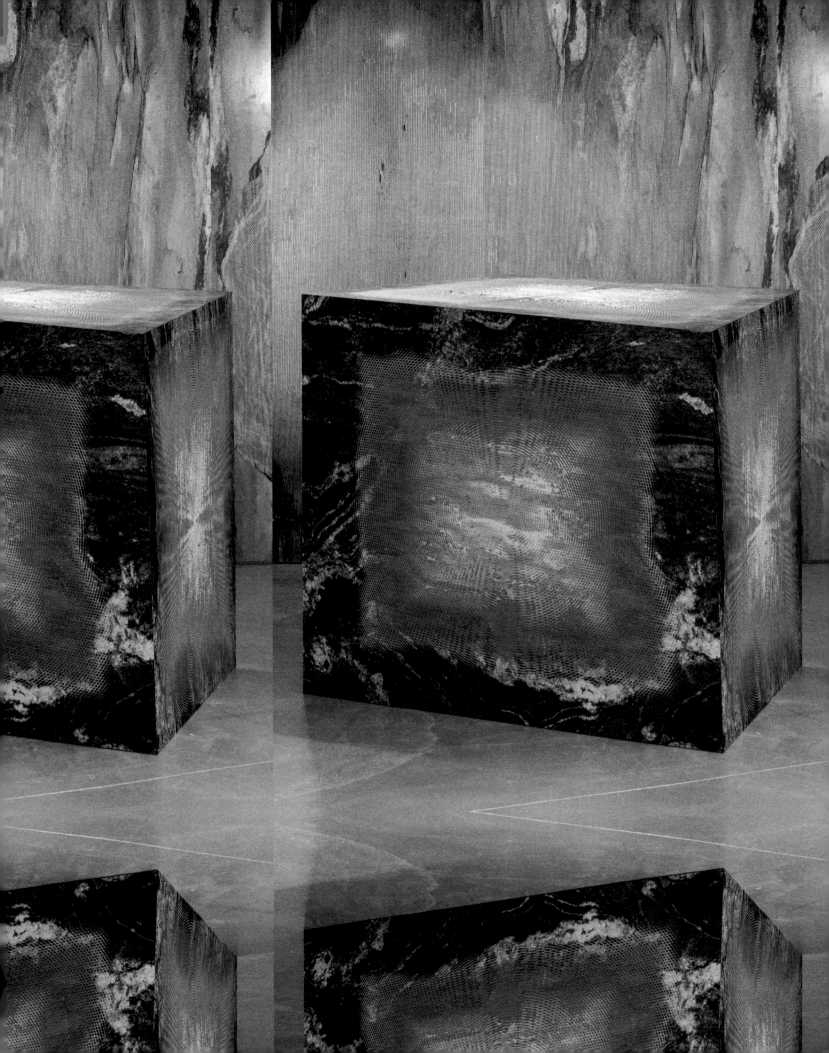

FUNDAMENTALS AND PRINCIPLES IN SCREEN-BASED LEARNING

AE Benenson

Chapter One:

Three Out-of-Body Experiences

I

Maria can see the tennis shoe with her eyes closed: two stories above her, stuck on a window ledge. It is 1977, at the Harborview Medical Center in Seattle and Maria's lying in a room with her eyes closed because technically she is dead. But she is also looking down on the hospital from above and now she can see the shoe. It's navy blue, with a scuff where the little toe would go and one lace is stuck under the heel. How did a tennis shoe get all the way up there anyway, Maria thinks to herself. This seems like an unlikely place for a tennis shoe to get stuck.

After the doctors restart her heart, Maria tells her caseworker Kimberly Clark about the tennis shoe. Go up and get it, she tells Kimberly, it's on the ledge of the third floor window on the other side of the hospital. You'll see. Kimberly tries Maria's bedside window and she can't see the shoe. Up on the third floor, she wanders from room to room, looking out each window, unable to see the shoe. Finally, she finds a window, where face pressed hard against the glass, she sees a shoe on a ledge. Scuff, tucked lace— exactly how Maria described it.

What defines an out-of-body experience is, paradoxically, the feeling that you have not moved. That, physically, you have stayed in the same place the whole time, but that whatever it is that lets you see things—not your eyes or your brain, surely, because those things, along with the rest of your body haven't moved—but whatever actually lets you see things has drifted off to some other point.

So an out-of-body experience isn't anything like a hallucination, because unlike a hallucination in the case of an out-of-body experience what you see is

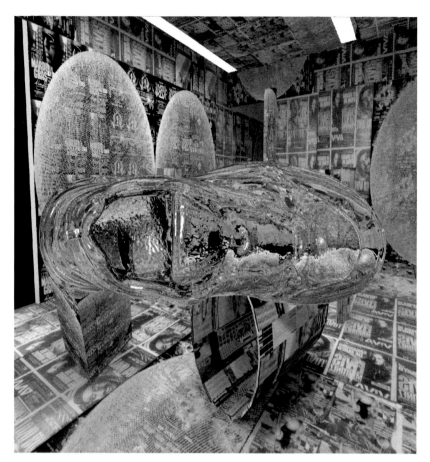

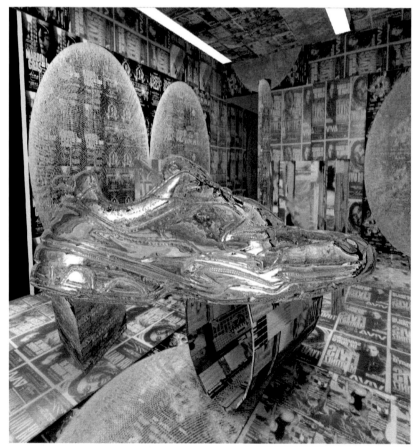

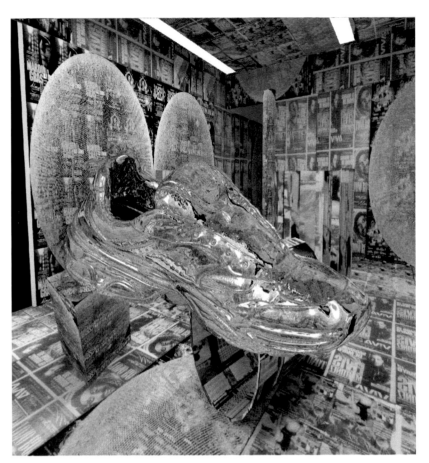

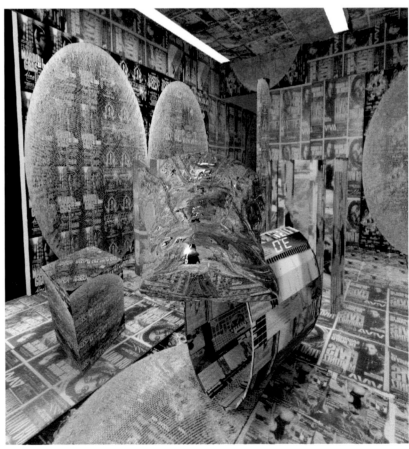

Figure 1 (opposite top)
Early interactive computer graphics were typically constrained to a single screen "top-down" perspective due to limited processing power.

Figure 2 (top)
The first video game to exist continuously across multiple screens, ie the first to have multiple "rooms" linked together at the edges, was Adventure, 1979. Because all previous video games had existed on single screens, the manual for Adventure had to explain the mechanic—so intuitive in the real world—of being able to pass from one connected space to another, to its players.

Figure 3 (opposite bottom)
Adventure also contained the first "easter egg" called the "gray dot".

Figure 4 (bottom)
Once retrieved from a hidden location, the "gray dot" allowed players to pass through a wall containing a secret room with the designer's credit.

actually there. And it's also nothing like a "vision" where some real thing comes and visits your senses, because your senses are the ones that are moving in this case. You are sure that you have seen actual things and events in situ. But you are also sure that you were not really there to have seen them—that you never moved at all.

In this way an out-of-body experience is also always a body-out-of experience. If normally we assume your body has to be present somewhere for you to see what is there, the out-of-body experience suggests that we can take your body out of the equation of seeing and perceiving— that your body can be taken out of a space and you can still see things in that space. What's more, it suggests that your body can be taken out of a space and you can still move around as if you were still attached to a body that was carrying around all your visual equipment for you. What has been taken out of your body—in the sense of freed from it—is your ability to move around a space and it contents while still seeing and perceiving.

How does the amputee feel when they still try to reach for a glass with a hand they no longer have? The philosopher Maurice Merleau-Ponty reasoned that the only way we could understand what it felt like to have a body was to pay attention to those liminal moments when you found yourself without one. Try to grab the glass. Try again. Touch the tennis shoe. Maybe you are dreaming it all up somehow, or maybe you are meeting these objects on different terms now. You still know what its like to have a body, how it makes you see and interact with things in a certain way, but it's also clear that those rules need not apply here, that there are others worth learning now.

Figure 5 (top)
Physical therapy done using a box with a mirrored wall has proven to be an effective treatment for phantom limb syndrome, wherein a patient suffers from pain from a body part that they no longer physically have.

Figure 6 (bottom)
For example, a patient places their right hand in the box so that by reflection it recreates the missing limb and then performs strengthening exercises.

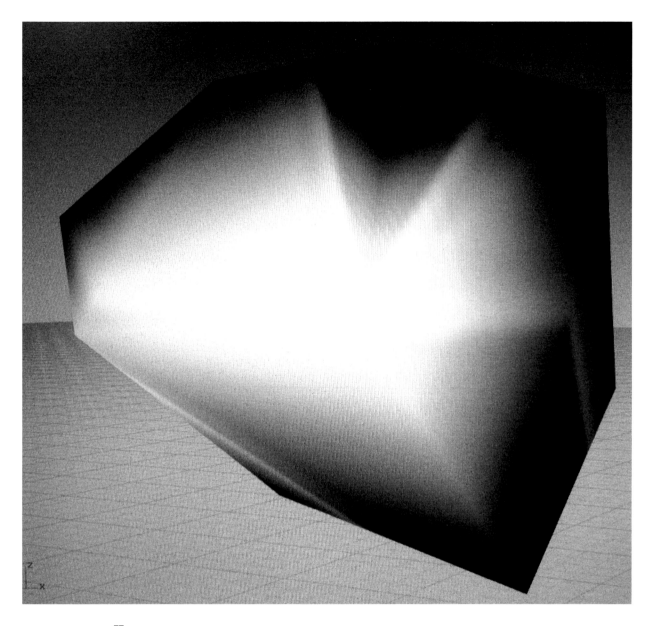

II

The written record has it that for a long time out-of-body experiences made up an integral part of that canon of near death experiences that, along with the white light and the over-cranked replay of one's life history, the untangling of perception from the body was something of a requisite experience from The Beyond: way station for the doomed and souvenir for the lucky.

There is, for example, also the near death experience of Albrecht Meydenbauer the German architect tasked with surveying the Wetzlar Cathedral in 1858. Too lazy or cheap to build a full scaffolding around the Cathedral, Meydenbauer decides to suspend himself inside a

basket from ropes and pulleys and slowly make his way down the facade like a precariously abandoned infant. Trying to enter one of the Cathedral's windows at dusk Meydenbauer slips, the basket swings away and in that moment he knows that he is about to fall to his death: "I grabbed the curved edge of an arch with my right hand and with my left foot I shoved the basket far into the air, the counter action sufficed to push my body into the opening."

Meydenbauer concedes that the basket is a death trap and will save him time and expense only in the sense that it will most likely kill him the next day. And so lacking any better ideas,

Figure 7

The majority of visual cues for depth perception are monocular, ie dependent only on one eye.

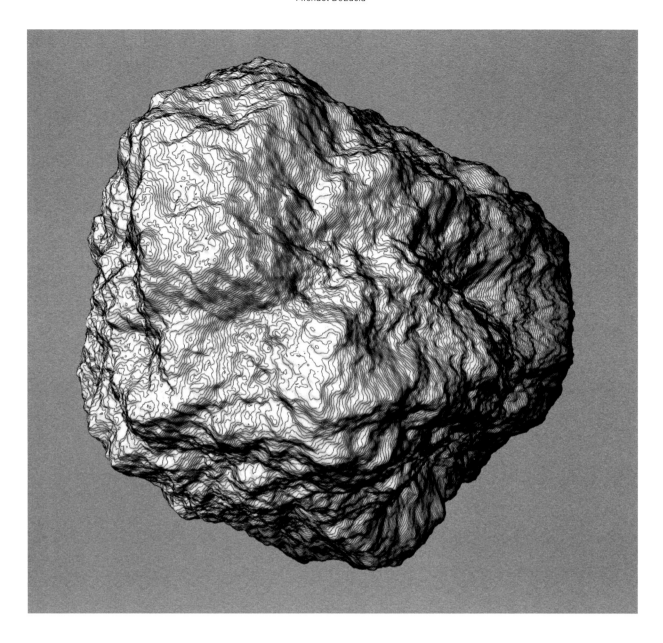

he becomes the first person to try to technologically simulate an out-of-body experience. The basic idea was that if a photographic image could be counted on to capture a scene in proper perspective (still very much a question this early on), then, by definition, a photograph also contained all the necessary information to make accurate three-dimensional measurements of its subject. In other words, Meydenbauer was the first to realize that you needn't have a body to explore three-dimensional space, you only needed a ingenious technology to escape it. Meydenbauer, had passed through the crucible of death, and now he knows he can take leave of his clumsy body, floating up and down buildings at will by grace of the new technology of photography, itself still occupying a position just to the right of paranormal.

In practice, it took Meydenbauer nearly three more decades to work out all sorts of practical problems with his idea—how to integrate a co-ordinate system into photo-plates, for example. But the premise was sound: the hellish rigs could be left to window cleaners; the body could be taken out of this equation altogether. In its place could stand the three-legged camera and through its images the disembodied eye could take its saccadic wonderings within any three-dimensional space capable of being imaged.

Figure 8

Joseph Smith, the prophet of the Mormon church, is said to have written the Book of Mormon by using a "seer stone".

Figure 9
*Smith was said to have "put the [stone]
in a hat, and put his face in the hat, drawing
it closely around his face to exclude the
light; and in the darkness the spiritual light
would shine".*

Figure 10
*Throughout his work, the golden plates from
which Smith translated were kept behind a
partition where he could not see them.*

III

William Fetter had wanted to call him "First Man" because that's what he had been: the first man built inside a computer in July of 1964. It was a good name, but Fetter worked for the aeronautics company Boeing and the First Man was technically the company's property so they had to call him Boeing Man instead.

Four years earlier, Fetter had coined the term "computer graphics", while digitally rendering the inside of a Boeing cockpit. Now the virtual world of computer graphics, still entirely described by the bubble of that lone Boeing cockpit, had its first inhabitant, Boeing Man: a wireframe man with seven moveable joints built to study and refine the ergonomics of the cabin—where the buttons and levers should be, how high the captain's seat had to be positioned, and most of all how all of this could be arranged in the minimum amount of space possible.

As we've come to know it through marketing, "ergonomics" means accommodation: a special place reserved for the body in the foreboding architecture of machines. In fact, people like William Fetter know the real goal of ergonomics is closer to something like the opposite. The body is a nuisance, a regrettable obstacle for the smooth function of technology, and the task is to figure out how to get it out of the way. An ideal ergonomic experience isn't one where a user feels comfortable, it's one where they feel nothing at all. If by chance a user happens to feel some part of their body while operating a piece of technology, Fetter knows it is only a cause for concern, a premonition of fatigue, distraction, pain, and inevitably, resignation. Fetter wasn't trying to build a better cockpit, he was trying to build a better out-of-body experience.

A user shorn of their body. This was the original practical application of computer graphics, what it hoped to contribute to the history of technology, to which its very First Man was dedicated. From the beginning then, computer graphics weren't simply representations of spaces and things, they were also representations of a new way in which we could perceive them without our bodies.

In this way, ergonomics is the name we could give that new set of rules that computer graphics set out for how the perception of objects could work without a body; for how a person could experience a space and its contents without being rooted in the sensation of their physical presence but instead following the conditions of digital processes. Objects perceived ergonomically can't be assumed to have specific sizes, weights, sensible textures, densities, or temperatures because ergonomics removes the body that feels those qualities; objects perceived ergonomically are liable to multiply without warning, change material, orientation, and scale or simply have none at all. Still ergonomic perception doesn't mean looking at images of things, just like an out-of-body experience doesn't involve hallucinations or visions; it means instead the paradox of moving and perceiving things in three dimensions without using our body. While strictly speaking this seems impossible, we could call this—that is, ergonomic perception—the paranormal asymptote that technology bends us towards.

Figure 11 (above)
The predominant visual motif of the first half of the twentieth century was that of speed; the second half, scale.

Figure 12 (opposite)
The Man Machine, 2015
high pressure laminate, plywood
48 x 96 x ¾ in
Collection of the Artist,
Courtesy of Eleven Rivington

Chapter Two:

Worth Believing In for the Time Being

In 1994, two researchers visited the Harborview Medical Center to investigate the story of Maria's out-of-body experience. They found that a shoe placed on the ledge where the original shoe had been found could be easily seen from various vantage points within the building, including from the windows of a number of the patients' rooms. In the concluding remarks to their white paper on the topic the researchers dismiss Maria's account, as well as its persistence in out-of-body literature, as a case of wishful thinking on the behalf of those who wanted to believe in its claims.

Figure 13 (opposite above)
*A recent study shows that over
50 per cent of social science studies'
findings cannot be reproduced
under any conditions.*

Figure 14 (opposite below)
*This new study was called the
"Reproducibility Project."*

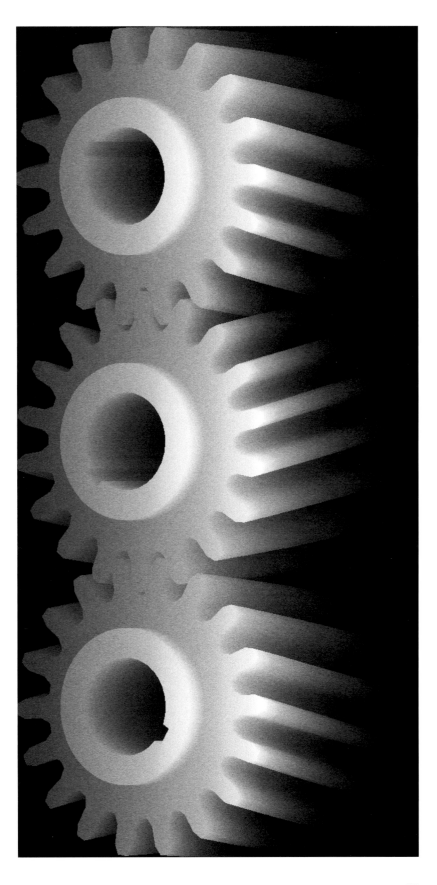

Figure 15 (right)
*Will it be possible to reproduce
this study?*

Chapter Three:

Observations On Some Other Remarkable Experiences Without Apparent Cause

You must conceive the observer placed at the foot of a hill interposed between him and the place where the sun is rising, and thus entirely in the shade; the upper margin of the mountain is covered with woods or detached trees and shrubs, which are projected as dark objects on a very bright and clear sky, except at the very place where the sun is just going to rise, for there all the trees and shrubs bordering the margin are entirely, branches, leaves, stem and all, of a pure and brilliant white, appearing extremely bright and luminous, although projected on a most brilliant and luminous sky, as that part of it which surrounds the sun always is. All the minutest details, leaves, twigs, etc., are most delicately preserved, and you would fancy you saw these trees and forests made of the purest silver, with all the skill of the most expert workman. The swallows and other birds flying in those particular spots appear like sparks of the most brilliant white.

**– LA Necker to
Sir David Brewster,
November 1832**

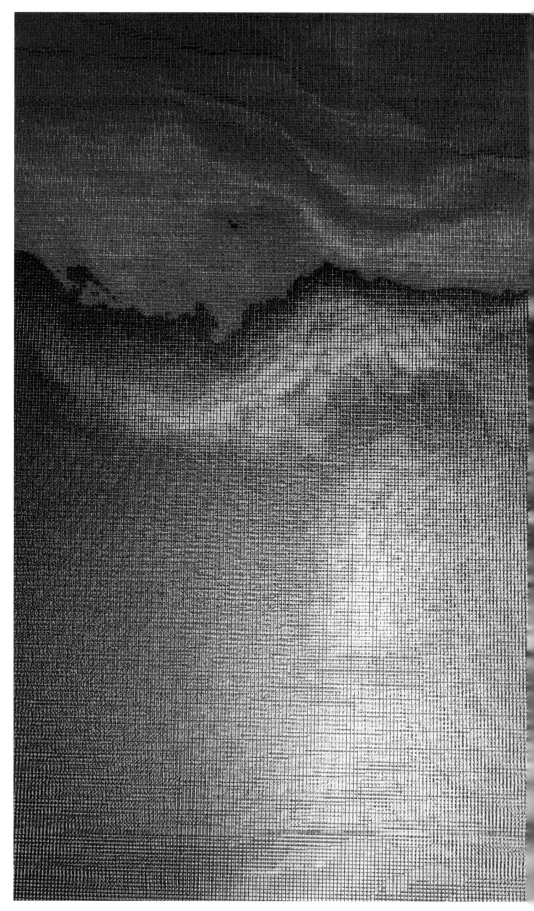

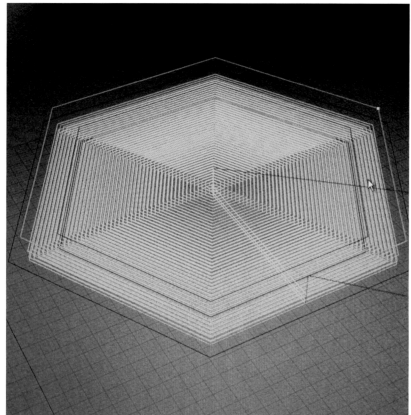

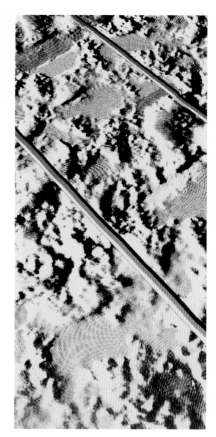

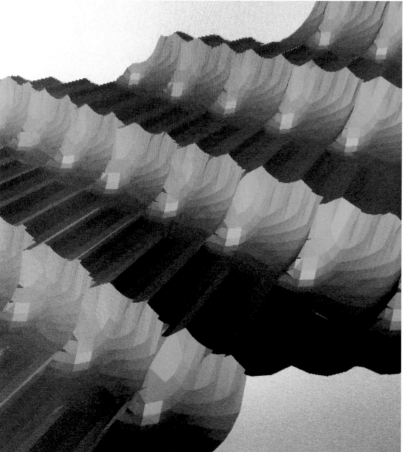

Figure 16 (top left)
Simultagnosia is a neurological disorder where the sufferer is unable to process visual input as a whole.

Figure 17 (top right)
Visual input is processed as a series of parts that can be understood and described on their own but cannot be formulated into a coherent image.

Figure 18 (opposite)
It has been suggested that those suffering from simultagnosia have "disengagement difficulty".

Figure 19 (bottom)
The impaired ability to shift one's attention from one object to another.

In the same letter the crystallographer LA Necker also discovered one of the simplest and most enduring examples of what's now called a multi-stable image: an isometric, wireframe cube angled so that its front-most edge and rear-most edge intersect with lines in the base of the cube. Drawn in such a way, the cube appears to pop back and forth between two different three-dimensional orientations depending on where you look. Necker was obsessed with crystalline illusions and he first came across the mysteries of the wireframe cube while looking at textbook engravings of diagrams of crystals as observed under microscopes: the ambiguous geometry of the line drawings making them coruscate like their real-life counterparts.

The Necker Cube belonged to a new kind of secular magic of perception inaugurated in the nineteenth century that included a range of optical illusions meant to simulate movement and interactivity through static images. Its predecessor were the sacred, magical images of the Middle Ages: depictions of the vera icons (true images) believed to have been originally made by divine machinery that represented their exceptional nature through making improbable use of their materials.

Vera icons are religious images made without human intervention— acheiropoetica, literally "made without hands". The Shroud of Turin is the most famous and also the least interesting. Far better is the Veronica, which unlike the artifact of the Shroud only exists— and almost certainly only ever existed— as something for artists to represent in their images. The Veronica was a sweat cloth belonging to the woman Veronica, whose name, when nudged in the Greek, predicts the whole story (Vera-Eikon).

As Christ climbs the hill to his crucifixion, Veronica wipes his brow and is rewarded with a miraculous picture of the Lord and Savior on her cloth. Unlike the Shroud of Turin, which plausibly looks like the marks a body could make on a cloth, woodcuts of the Veronica always depict an illustration of Christ's face drawn like a portrait. Art Historian Otto Pacht describes the weird leap between modes of representation: "the supple cloth molds the three-dimensional object, but when it is again spread out as a plane surface, it shows the object's impression

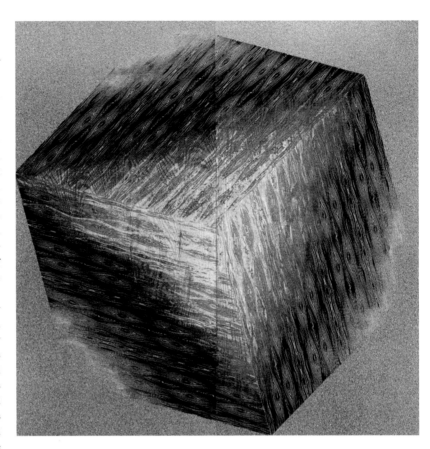

as a picture…" This ability to model a three-dimensional object, without the apparent intervention of a human hand to translate its features, describes the cloth's divine algorithm, its acheiropoetic magic. Those artists who put themselves to the task of representing the Veronica in the woodcuts of the fifteenth and sixteenth century redoubled the workings of this divine machine onto the surface of their own material, making meta vera icons. Here's Joseph Leo Koerner on a relevant example:

Instead of allowing the picture plane to vanish into the illusion of a represented scene… the Cologne master keeps the eye fixed on the tooled surface of the panel, on its material presence. And since the absolute 'foreground' of this image is constituted by the vera icon itself, the whole work of art becomes consubstantial with its magical subject, aspiring thereby to the status of the relic itself.[1]

By making the woodcut's surface also the surface of the Veronica, these Renaissance artists turned the grooved surface of the woodcut into a kind of technological surface capable of the three-dimensional rendering that it depicts in its biblical subject matter. The surface of the woodcut exceeds its use as a material for displaying a narrative and becomes a site of production whose abilities seem to exceed those of its actual materials. In short, the surface becomes an active, technological surface running a representational program by virtue of the special image that comes to inhabit it. The woodcut adopts the techno-magical properties of Veronica's veil by depicting it. Here's an alternate explanation for how technological screens come to exist in the world. It claims that things can become technological screens even when they aren't built with that use in mind; that the right kind of image carries with it the means to momentarily turn something prosaic—paper, cloth, wood—into an active technological interface upon which renderings can both be passively represented and actively constructed. Necker's wireframe engraving of a crystal shimmers on the page and momentarily,

Figure 20 (opposite)
Crate, 2013
high pressure laminate, plywood
96 x 96 x ¾ in
Mellado Collection, Miami

Figure 21 (top)
The second commandment explicitly condemns the production of images.

Figure 22 (bottom)
Therefore the concept of art within the Judeo-Christian tradition is rendered nonsensical.

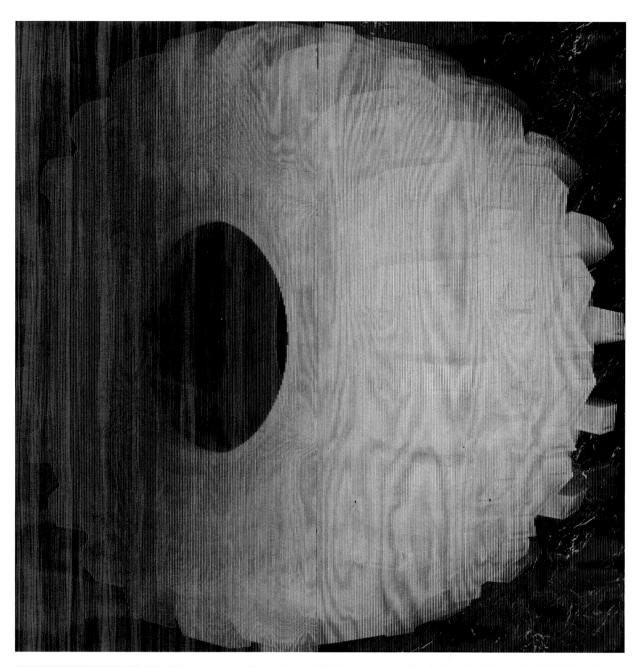

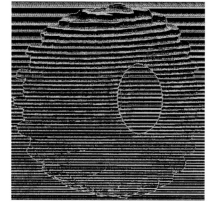

Figure 23 (left)
*We see the return of the term "magic"
in descriptions for digital editing tools
whose methods are otherwise too
difficult to explain to the lay-user.*

Figure 24 (opposite top)
Untitled, 2013
high pressure laminate, plywood
96 x 96 x ¾ in
Krawiecki Gazes Family Collection

Figure 25 (opposite bottom left)
The magic wand tool.

Figure 26 (opposite bottom middle)
The magic lasso tool.

Figure 27 (opposite bottom right)
The magic eraser tool.

even though Necker can't possibly know this yet, it transforms into a version of a liquid crystal display (LCD), a screen that also twists arrays of crystals back and forth to generate its images.

If this is a kind of technological magic, it's closest to animism—meaning that materials can be possessed by images with something of the spirit of their invention. They depict something—Jesus' face, a cubic crystal—but in doing so they also compel their materials to reperform the magic of the original creation witnessed in their depictions. They are a material but also an experience. The Gestalt psychologists call things like the Necker Cube multi-stable images because they maintain two different states at once; Koerner calls his subjects consubstantial, referencing the Christian doctrine where wine can be itself and holy blood at the same time. The medieval intuition that all this has to happen without human hands, if not by way of God, abides today in all those digital processes that surrogate the artist's touch. Those who complain about a loss here, who regret that humans have been taken out of the aesthetic process of making by technology, fail to appreciate what acheiropoetica offers in place of process. Images and objects made without human hands understand that the artist is a witness to an inexplicable experience, and in turn they aspire to impart that experience onto the viewer. This is the special privilege of acheiropoetica that remains unavailable to those works that only serve as records of what the artist has done to some material.

1 Koerner, Joseph Leo, *The Moment of
 Self-Portraiture in German Renaissance
 Art*, Chicago: University of Chicago
 Press, 1997, p 90

pp 26–27
Untitled, 2011
plotted drawing (ink on paper)
18 x 24 in
Collection of the Artist

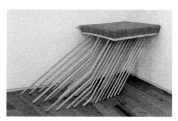

pp 28–29
Redshift, 2007
push brooms
45 × 50 × 80 in
digitally manipulated image

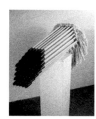

p 30
Back to the Future, 2007
deck mops
60 × 27 × 23 in
Collection of the Artist

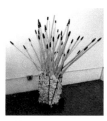

p 31
Car Bomb, 2007
grocery cart, deck mops
approx 40 x 49 x 50 in (dims variable)
Collection of Timothy DeLucia

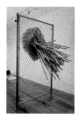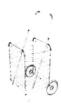

p 32
Grocery Cart, 2008
plotted drawing (ink on paper)
18 x 24 in
Belgian Private Collection

p 33
Untitled (fence with mops), 2007
galvanized chain link fencing, deck mops
97 × 58 × 59 in
Private Collection

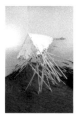

p 34
Corner, 2010
deck mops, plaster
approx 55 × 55 × 55 in (dims variable)
Private Collection

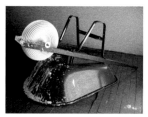

p 35
Revolution, 2008
wheel barrow, plaster
52 × 28 × 25 in
Collection of the Artist

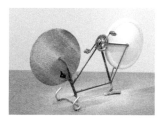

p 36
Of Primitive Means, 2009
bicycle frame, wood, plaster
42 x 71 x 19 in
Galizaz' Collection, Belgium

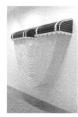

p 37
Community, 2009
aluminium awnings, rope
84 × 84 × 24 in.
Private Collection, Lyon

pp 38–39
Uneven Rotation (90 deg.), 2009
plotted drawing (graphite on paper)
18 x 24 in
Collection of the Artist
Courtesy of Galerie Nathalie Obadia

p 40
Pentagon Bite, 2008
expanded polystyrene
30 x 24 x 23 in
Proximus Art Collection, Belgium

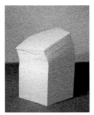

p 41
Interruption, 2009
expanded polystyrene
30 x 24 x 23 in
Collection of the Artist

p 42
Barrel, 2008
expanded polystyrene, inflatable stools
50 × 50 × 56 in
Collection of the Artist
Courtesy of Galerie Nathalie Obadia

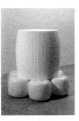

p 42
The Age of Bronze, 2008
expanded polystyrene
56 x 41⅜ x 41⅜ in
Marneffe, Belgium

p 43
Sweep with Dusters, 2008
expanded polystyrene, dusters
47¼ x 34¼ x 52 in
Private Collection, Belgium

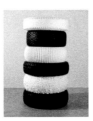

p 44
Try, Try, Try Again, 2008
expanded polystyrene, tires
52 × 29 × 29 in
Nadia et Thierry Lambot, Belgium

p 45
Gorilla (no.1), 2014
plotted drawing (graphite on paper)
18 x 24 in
Collection of the Artist
Courtesy of Galerie Nathalie Obadia

p 46
Pyramid, 2010
OSB, safety enamel
96 × 48 × ¾ in
Private Collection

p 46
Box, 2010
OSB, safety enamel
96 × 48 × ¾ in
Private Collection

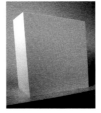

p 47
Rhombus, 2007
expanded polystyrene
42 × 48 × 24 in
Collection of the Artist

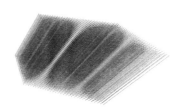

pp 48–49
Rhomboid, 2008
plotted drawing (graphite on paper)
18 x 24 in
Collection of the Artist
Courtesy of Galerie Nathalie Obadia

p 50
Black Coil, 2010
OSB, safety enamel
96 × 48 × ¾ in
Private Collection

pp 50–51
Horizontal Coil, 2010
OSB, safety enamel
96 × 48 × ¾ in
Private Collection

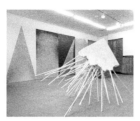

pp 52–53
exhibition view
Michael DeLucia, 2010
Eleven Rivington, NYC

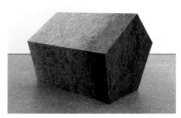

pp 54–55
Untitled, 2010
OSB, spraypaint
41 x 29 x 28 in
Collection of the Artist

p 56
Sphere (blue/black), 2011
OSB, safety enamel
96 x 96 x ¾ in
Sunnen Collection, France

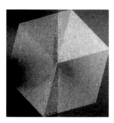

p 57
Cube (black/green), 2011
OSB, safety enamel
96 x 96 x ¾ in
Pedotti Collection, Mexico

p 58
Untitled, 2011
plotted drawing (ink on paper)
18 x 24 in
Collection of the Artist
Courtesy of Eleven Rivington

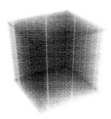

p 59
Untitled, 2011
plotted drawing (ink on paper)
18 x 24 in
Collection of the Artist
Courtesy of Eleven Rivington

p 60
Can, 2011
OSB, spraypaint
30 × 30 × 48 in
Collection of the Artist

p 61
Log, 2011
plywood, safety enamel
24 x 48 x 24 in
Private Collection, Belgium

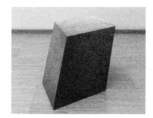

p 62
Prism, 2011
OSB, safety enamel
24 x 54½ x 20 in
Collection Kervyn, Belgium

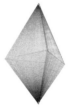

p 63
The Primitive, 2011
plotted drawing (ink on paper)
18 x 24 in
Private Collection, Luxembourg

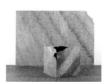

pp 64–65
Artifact, 2011 (front)
plywood, safety enamel
36 x 36 x 36 in
Interference, 2011 (back)
plywood, safety enamel
144 x 96 x ¾ in
Collection of the Artist

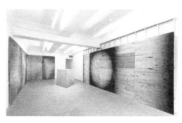

pp 66–67
exhibition view
Michael DeLucia, 2012
Eleven Rivington, NYC

p 68
Cube (Projection 5), 2012
plywood, shellac
48 x 96 x ¾ in
Private Collection

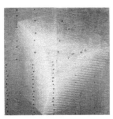

p 69
Cube (Projection 4), 2012
plywood, shellac
96 x 96 x ¾ in
Private Collection

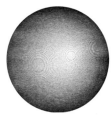

p 70
Weight, 2011
plotted drawing (graphite on paper)
18 x 24 in
Private Collection, Belgium

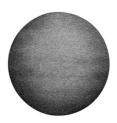

p 71
Heavy Point, 2011
plotted drawing (graphite on paper)
18 x 24 in
Private Collection, Belgium

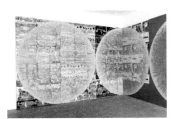

pp 72–73
exhibition view
Michael DeLucia, 2012
Eleven Rivington, NYC

p 74
The Round Sound, 2012
OSB, found posters
96 x 96 x ¾ in
Collection of the Artist

p 75
Untitled, 2012
OSB, found posters
96 x 96 x ¾ in
Private Collection

p 76
Prism, 2012
OSB, posters
96 x 48 x ¾ in
Private Collection, Belgium

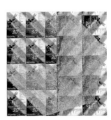

pp 76–77
Cube, 2012
OSB, posters
96 x 96 x ¾ in
Private Collection, Belgium

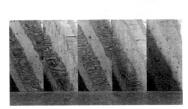

p 78
Iteration, 2012
plywood, enamel
240 × 96 × ¾ in
Private Collection, London

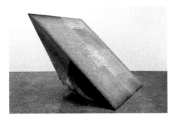

p 79
Projection, 2012
plywood, safety enamel
96 × 68 × 68 in
Collection of the Artist

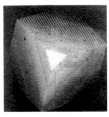

p 80
Untitled 2011
plywood, enamel
96 x 96 x ¾ in
Collection of the Artist

p 81
Projection (hunter green), 2012
plywood, enamel
96 x 96 x ¾ in
Collection of the Artist

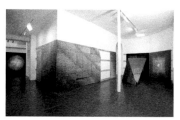

pp 82–83
exhibition view
Michael DeLucia: Projections, 2012
Galerie Nathalie Obadia, Paris

p 84
Glint, 2013
plywood, safety enamel
48 x 96 x 48 in
Collection of the Artist
Courtesy of Galerie Nathalie Obadia

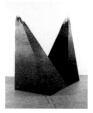

p 85
Double Spot, 2012
plywood, safety enamel
48 × 96 × 96 in
Collection of the Artist

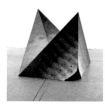

p 85
Untitled, 2013
plywood, safety enamel
36 × 36 × 36 in
Collection of the Artist

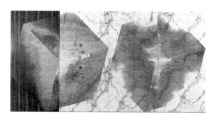

pp 86–87
Crop Circles, 2013
high pressure laminate, plywood
144 × 96 × ¾ in
Collection Peter Remes

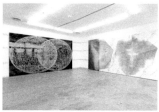

pp 88–89
exhibition view
Michael DeLucia: Eye of Providence, 2013
Eleven Rivington, NYC

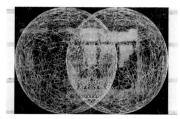

pp 90–91
Spaceballs, 2013
high pressure laminate, plywood
144 × 96 × ¾ in
Private Collection

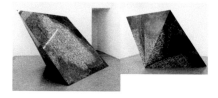

pp 92–93
Stephen Hawking, 2013
high pressure laminate, plywood
96 × 68 × 68 in
Collection of the Artist

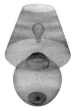

p 94
Lamp, 2010
plotted drawing (graphite and
ink on paper)
18 x 24 in
Private Collection, France

p 95
Reflection and Refraction, 2014
high pressure laminate, plywood
96 x 48 x ¾ in
Ghisla Art Collection, Switzerland

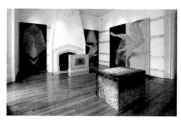

pp 96–97
exhibition view
Michael DeLucia, 2014
Anthony Meier Fine Arts, San Francisco

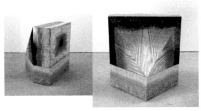

pp 98–99
Noisebox, 2014
high pressure laminate, plywood
36 × 36 × 36 in
Collection of the Artist
Courtesy of Anthony Meier Fine Arts

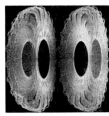

pp 100–101
Seeing is Believing, 2014
high pressure laminate, plywood
96 x 96 x ¾ in
Ghisla Art Collection, Switzerland

p 100
Available Light, 2014
high pressure laminate on plywood
96 x 48 x ¾ in
Bendit Collection
Courtesy Pettit Art Partners, New York, NY

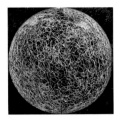

pp 100–101
Planet of the Apes, 2014
high pressure laminate, plywood
96 x 48 x ¾ in
Collection of the Artist

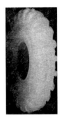

p 101
101 Round and Round, 2014
high pressure laminate, plywood
96 x 48 x ¾ in
Ghisla Art Collection, Switzerland

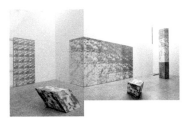

pp 102–103
two exhibition views
Michael DeLucia: La Pomme de Terre
du Ciel, 2014
Galerie Nathalie Obadia, Brussels

pp 104–105
Sublimation, 2014
high pressure laminate, plywood
144 × 96 × ¾ in
Collection of the Artist
Courtesy of Galerie Nathalie Obadia

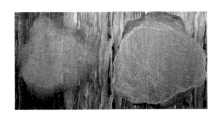

pp 106–107
Dense Fog and *Float Like a Stone*, 2014
high pressure laminate, plywood
192 x 96 x ¾ in
Jacques and Christiane Berghmans
Collection, Belgium

p 108
Asteroid, 2014
plotted drawing, (graphite on paper)
18 x 24 in
Collection of the Artist
Courtesy of Galerie Nathalie Obadia

p 108
Boulder, 2014
plotted drawing, (graphite on paper)
18 x 24 in
Private Collection, Belgium

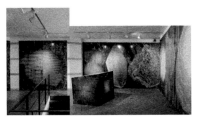

pp 110–111
two exhibition views
Michael DeLucia: La Pomme de Terre
du Ciel, 2014
Galerie Nathalie Obadia, Brussels

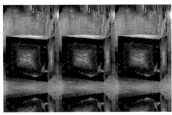

pp 112–113
Boulder, 2014
high pressure laminate on plywood
48 × 48 × 48 in
composite image

MICHAEL DELUCIA

Born 1978 in Rochester, NY
Lives and works in New York, NY

EDUCATION

2004 MA, Sculpture, Royal College of Art, London, UK
2001 BFA, Sculpture, Rhode Island School of Design,
 Providence, RI

SOLO EXHIBITIONS

2015 Appearance Preserving Simplification, Museum of
 Contemporary Art Santa Barbara (MCASB),
 Santa Barbara, CA
2014 La Pomme de Terre du Ciel, Galerie Nathalie
 Obadia, Brussels, Belgium
 Michael DeLucia, Anthony Meier Fine Arts,
 San Francisco, CA
2013 Eye of Providence, Eleven Rivington, New York, NY
2012 Projections, Galerie Nathalie Obadia,
 Paris, France
 Michael DeLucia, Eleven Rivington, New York, NY
2011 Luce Gallery, Turin, Italy
 Galerie Nathalie Obadia, Brussels, Belgium
2010 Michael DeLucia, Eleven Rivington, New York, NY
2009 Community, Galerie Nathalie Obadia,
 Paris, France
2008 Michael DeLucia: Nouvelles Oeuvres, Galerie
 Nathalie Obadia, Brussels, Belgium
 Michael DeLucia: New Sculpture, Alan Koppel
 Gallery, Chicago, IL

GROUP EXHIBITIONS

2015 Inaugural, Lyles and King, New York, NY
 Revisiones, Galeria Impakto, Lima, Peru
2014 David Kennedy Cutler, Michael DeLucia, David
 Scanavino, Derek Eller Gallery, New York, NY
2013 Socrates Sculpture Park, Long Island City, NY
 Ether Scrims, Dark Rooms and Calculative
 Planes: Michael DeLucia, Bryan Graf and
 Kate Shepherd, Halsey McKay Gallery,
 East Hampton, NY
 On the Grid, Lu Magnus, New York, NY
 MONSALVAT, Bureau Gallery, New York, NY
2012 80WSE Presents, 80wse Galleries, New York, NY
 Hors les Murs, Galerie Nathalie Obadia,
 Brussels, Belgium
 Coquilles Mécaniques, Centre Rhénan d'Art
 Contemporain (CRAC), Alsace, France
 In Between, Galerie Nathalie Obadia,
 Brussels, Belgium

Lizzi Bougatsos, Michael DeLucia, Lizzie Fitch,
David Gilbert, Robert Overby, Andra Ursuta;
Andrea Rosen Gallery, New York, NY
Flection, Hedge Gallery, San Francisco, CA
Potential Images, 1708 Gallery, Richmond, VA
In Practice: You Never Look at Me From the
Place From Which I See You, Sculpture Center,
Long Island City, NY
2011 Perfectly Damaged, Derek Eller, New York, NY
 Tablet, Eleven Rivington, New York, NY
 Against the Way Things Go, Gasser and Grunert,
 New York, NY
2010 The Coke Factory, Ritter/Zamet, London, UK
 Neither Swords Nor Plowshares: Functional
 Futilities, Cerritos College, Norwalk, CA
 The Every Other Day, Ideobox Artspace, Miami, FL
 One Acre Plot, Majestic Farm, Mountain Dale, NY
2009 Double Take, Public Art Fund, MetroTech Center,
 Brooklyn, NY
 Material Evidence, loop-raüm für aktuelle unst,
 Berlin, Germany
 Never Odd or Even and What Was, What Wasn't,
 What Will Never Be: Michael DeLucia and Luke
 Stettner, Kate Werble Gallery, New York, NY
 Linkage: Artists Select Artists, Museum of
 Contemporary Art, Detroit, MI
2008 Thursday the 12th, Kate Werble Gallery,
 New York, NY
 In Transit, Moti Hasson Gallery, New York, NY
 Tensegrity, Klaus von Nichtssagend Gallery,
 New York, NY
 Transito Alternitos, Ex Convento del Carmen,
 Guadalajara, Mexico
2007 Red Badge of Courage, Newark Arts Council,
 Newark, NJ
 AGRO BONGO, Rivington Arms Gallery,
 New York, NY
2006 The Hollow Salon, Hollow Gallery, London, UK
2005 Transfiguration, Pearlfisher Gallery, London, UK
 New Romantic, The Hospital Gallery, London, UK
 Siege, Siege House, London, UK
2004 The Show 2004, RCA degree exhibition,
 London, UK
 The Face 2004, The Gallery in Cork Street,
 London, UK
2003 Hunde, Hockney Gallery, London, UK

BIBLIOGRAPHY

2015	Sheets, Hilarie M, "Artist Michael DeLucia asks, What is real?", *Introspective magazine*, 1stdibs.com
2014	Akel, Joseph, "Michael DeLucia, Anthony Meier Fine Arts", *Modern Painters*, 18 December
	Lippman, Elizabeth, "Art Basel Miami Beach Continues Season's Fast Pace", *The Wall Street Journal*, 5 December
	"Solo exhibition by Michael DeLucia opens at Galerie Nathalie Obadia", Brussels ArtDaily.org, 10 November
2013	Halle, Howard, "Top five shows: Eleven Rivington", 28 October
	"6 of Our Favorite Booths at NADA New York", Artspace.com, 12 May
	Viveros-Fauné, Christian, "A critic's guide to the satellite fairs: the blue devils of Nada", The Art Newspaper, 11 May
	Russeth, Andrew, "Monsalvat at Bureau", The New York Observer, January
2012	Hoberman, Mara, "Michael DeLucia", *Artforum*, December
	Archey, Karen, "Review: Michael DeLucia Eleven Rivington", *Modern Painters*, September
	Demeulemesster, Thijs, "Wie Koopt Dat?", *Sabato de Tijd*, 12 May
	Kazakina, Katya, "NADA", bloomber.com, 1 May
	Langouche, Lisbeth, "Art Brussels: diversité tous azimuts," *Collect Art and Antiques*, April
	"Un avant goût d'Art Brussels", *Exponaute*, 2 April
2011	"Les galeries: Michael DeLucia", *Arts Libre*, November
	Johnson, Ken, "Art in Review: 'Perfectly Damaged'", *The New York Times*, 7 July
	Azimi, Roxana, "La revanche des Young American Artists", *L'oeil*, May
	"5 Bonnes Raisons de Voir l'Expo 'Michael DeLucia - Recent Works'", *Victoire (Le Soir)*, 9 April
	Sterckx, Pierre, "Michael DeLucia: la sculpture du XXI siècle", *MAD (Le Soir)*, 9 February
2010	Asfour, Nana, "Michael DeLucia Fancifully Transfigures the Mundane", *Time Out New York*, 17 December
	Sutton, Benjamin, "Knock on Wood; Most Artists Did in 2010", *The L Magazine*, 22 December
	Sterckx, Pierre, "Jeunes artists contemorains: les choix de trios experts", *Le Marchè de l'Art*
2009	Sterckx, Pierre, "Michael Delucia," *Beaux Arts Magazine*, December
	Vogel, Carol, "Playful in Brooklyn", The New York Times, 22 October
	Public Art Fund, "PublicArt Fund Presents 'Double Take'", October
2008	Artner, Alan, "Michael DeLucia," *The Chicago Tribune*, 24 October
	Kalm, James, "Tensegrity", *WagMag*, 1 July
	Stettner, Luke, "Interview with Michael DeLucia", *The Highlights*, Issue V
	"Cool Hunting Video Presents: Michael DeLucia", Coolhunting.com, 8 January
2007	Cohen, David, "Catching the Crest of the L.E.S. Wave", *The New York Sun*, 8 November
	Kerr, Merrily, "Agro Bongo", *Time Out: New York*, 9 November
	"Welcome to Newho", *New York Press*, 7 November

AWARDS

2013	Socrates Sculpture Park, Emerging Artist Fellowship
2011	Commision: Pioneer Companies, Syracuse, NY
2009–2010	Commission: Public Art Fund at MetroTech Center, Brooklyn, NY
2004–2005	Research Assistantship, RCA, London, UK
2003	Tiranti Prize, The Society of Portrait Sculptors, London, UK
	The Parallel Prize, London, UK

COLLECTIONS

Franks-Suss Collection, London, Sydney, Hong Kong
Rachofsky Collection, Dallas, TX
Rubell Family Collection, Miami, FL
Vanhaerents Collection, Brussels
Zubludowicz Collection, London, UK
Proximus Art Collection, Belgium
Ghisla Art Collection, Switzerland
Collection RAJA, Fondation Pour la Sculpture
Contemporaine, Villa Datris, L'Isle-sur-la-Sorgue, France

CONTRIBUTORS

Kristen Chappa is a curator and writer based in Brooklyn, New York. She is currently the Curator and Programs Manager at Art in General, and an International Curator in Residence at 221A in Vancouver, BC. She has organized exhibitions, performances, and public programs with Art in General (New York, New York), The KIM? Contemporary Art Centre (Riga, Latvia), SculptureCenter (Long Island City, NY), The Lab (San Francisco, CA), the Vera List Center for Art and Politics (New York, NY), and Volunteer Lawyers for the Arts (New York, NY). Chappa has contributed texts to publications for the International Studio & Curatorial Program (ISCP), Performa, SculptureCenter, and the Wallach Art Gallery at Columbia University, and has written for periodicals including *Art in America*, *Frieze*, and *Interventions Journal*. Chappa holds a BFA from the Rhode Island School of Design and an MA from Columbia University's Modern Art History: Critical and Curatorial Studies program.

AE Benenson is a writer and curator based in New York. His work explores how the formal vocabulary of contemporary technology can revise the histories of art, materials, and politics. He is Associate Curator at The Artist's Institute, New York City.